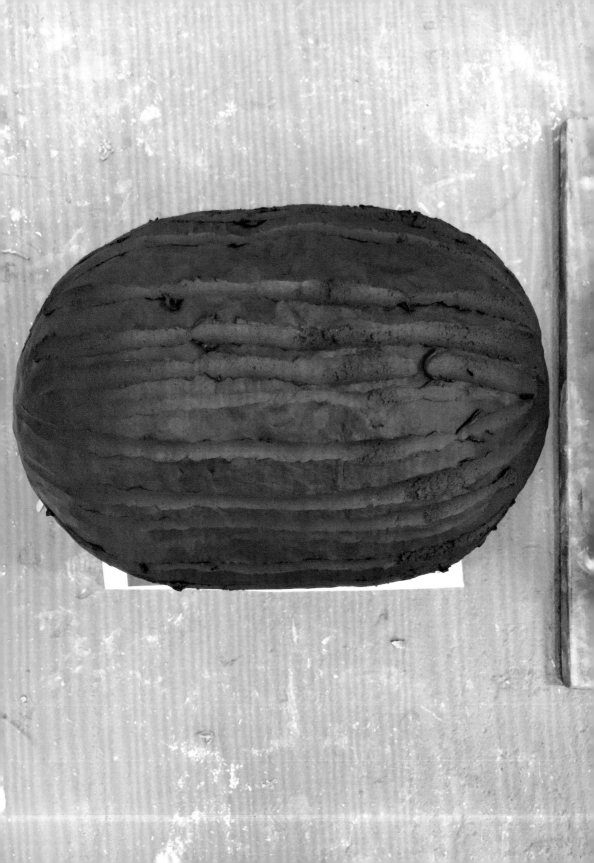

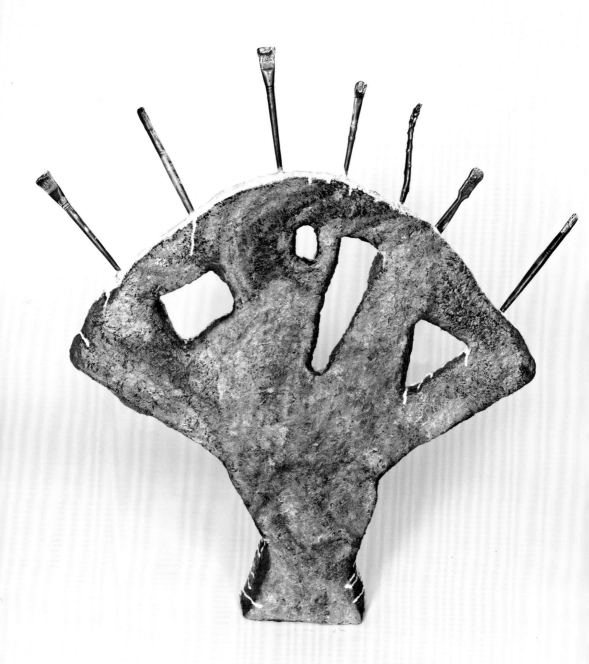

OPENER 28

ERIKA VERZUTTI

MINERAL

IAN BERRY

THE FRANCES YOUNG TANG
TEACHING MUSEUM AND ART GALLERY
SKIDMORE COLLEGE

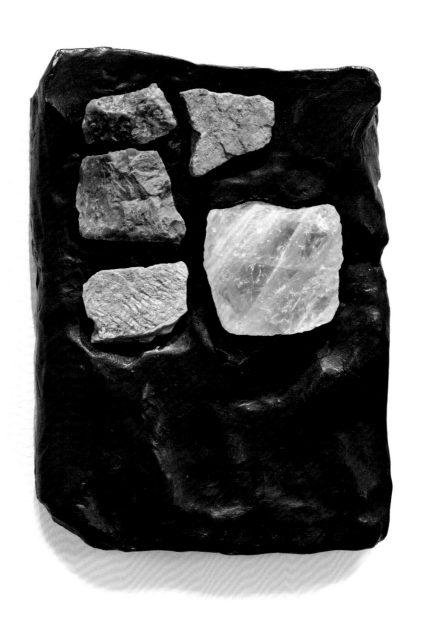

INCORRECT BEAUTY

A DIALOGUE WITH ERIKA VERZUTTI BY IAN BERRY

A field of bronze, concrete, clay and wax sculptures marks this first solo museum exhibition for São Paulo-based artist Erika Verzutti (b. 1971). Verzutti's works often combine dissimilar elements, such as references to everyday objects like fruits, vegetables, and eggs, with ceremonial forms, such as totems, tablets, and gravestones. Imbued with a sense of mysterious ritual, and mixed with a sly, surrealist humor, Verzutti's works often pay special attention to forms found in nature and life's constant mix of banality and beauty.

Erika Verzutti: I don't feel like I should say anything. I'm curious; I want to hear things.

I'm feeling bad and good. The bad feeling is that I'm so common. And the good feeling is I'm so common; it's the same thing. It's okay. I'm alive.

Ian Berry: I think that's exactly the way to describe the objects you make, and even the ways you make them. The words organic and natural come up a lot, because in your work there are things that look like nature: melons, sticks, rocks. But organic can also mean the way you're talking about it, how we feel when we get up in the morning and what we see when we walk down the street—a more holistic version of organic. You're having a life.

(facing)

Incrustado, 2013
Bronze and stones
11½ x 8 ¼ x 2⅛ inches

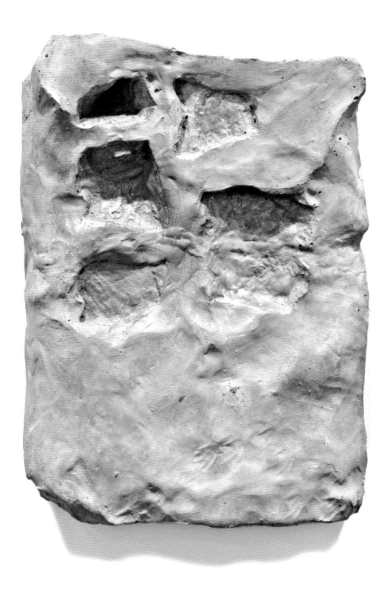

The Book of Gems,
2013
Concrete and wax
11½ x 9 x 2 inches

EV I like this idea that I'm having a life. I never know when it was that I was working and how that work got done, because I don't have a routine. The perception I have is that I'm never working. Or that I am working all the time. But it's more that I'm never working. I don't know how I manage to get things done.

IB Do you work by yourself?

EV I work with my brother all the time now. I feel powerful working with him and sometimes I end up making bigger pieces than I would make alone. We have also developed some vocabulary within the work, so I can say things like, "Let's make a squared chapel geode with watery texture skin." That keeps things moving.

IB Your studio is at home?

EV My studio is my living room. It's spacious. There is a kitchen in the studio space. And between the kitchen and the studio space, there is a TV and a sofa. All this goes together. It is kind of a twenty-four hour thing. And we work more during the night. That's why it must be at home; otherwise, I cannot organize myself to be in another place in town that I will feel safe to get back to, or be alone in at late hours.

IB Do you ever feel like you have to get out of the house?

EV I do. I stay there for days, sometimes. When I don't know what to do, I go to the movies, because then I still feel productive somehow.

IB How does it feel like you're still working? Because you're seeing somebody else's artwork?

EV Yeah. And I relate to movies. They're easy. I feel that I'm being informed, I feel that I'm seeing somebody's work, but in a way that I don't have to commit to. It's also a real life thing, not an art world frame.

IB What movies do you remember recently?

EV Remember we were talking about [Sacha Baron Cohen's] *The Dictator*

yesterday? Comedy is so important to me. I went twice, and I took my nephew and my niece to see it, as if I was educating them [laughs]. Which is a bad thing. It was politically incorrect, but extremely funny because it was allowed to be so incorrect. That's something everybody's looking for, a place for all the junky, incorrect stuff that usually is put away or hidden.

IB Some artists find those moments in their artwork. But if you're speaking in public, if you're putting your art or your movie in front of other people, and you're telling a joke about something horrible, it can feel very risky. Do you ever feel that way when you're putting a sculpture out? When you've made it and it feels funny to you, it feels perfect to you in some awkward way, and then, oh, what's the world going to do with these things? Do you worry about how your sculptures will be received?

EV I know I felt like that, but I cannot remember a piece doing something risky. The way I quote Brazilian modernists, maybe. Or Picasso. Sometimes I don't know how much of that is a joke. It's probably more of a serious quote, but I'm hiding behind some funny way to put it out; otherwise I wouldn't have the courage. But I know that feeling of being very satisfied, and the next day, when the exhibition opens, feeling the eyes of others and being afraid. I'll think, "Maybe I went too far."
If it's too bad, I take it down. I can't deal with being too uncomfortable. But it's a high.

IB The high gives you energy for making more sculpture?

EV **Yeah. There's anxiety to share and it has to be in there.**

IB Do you think you would make sculpture if you didn't have a place to show it? If there were no one to see it, would you still make it?

EV **No, I wouldn't make it.**

IB It's for people?

EV **Yeah.**

Turtle Turtle Modern,
2007
Bronze and plasticine
6⅛ x 7⅞ x 5⅛ inches

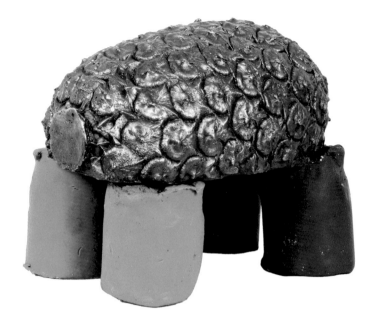

IB It's for communication.

EV **Yes.**

IB The feedback is important to you.

EV **It is.**

IB Is it hard when a sculpture leaves you and goes away, and you don't know where it is?

EV **No. No. I am happy for it to be out in the world. I know I will have the image, or the memory of it, or that it's documented somewhere. It's going to be online and I can always find it very quickly. Digital imagery changed the way an artist exists now. I remember the big thing, when I started, was to get slides done. If you had no slides, you were no artist.**

IB It's interesting how that's changed so quickly.

EV **Yeah. And so I feel much closer to the work I make.**

IB You say, "when I started"—when was that? In school, after school?

EV **In the middle of school.**

IB It felt like a starting point for you?

EV **Yeah, because it was not art school. I started going to artists' workshops and summer courses. Then there was the Goldsmiths episode, when I**

Samambaia, 2004
Found paper
14⅝ x 15¾ x 15¾ inches

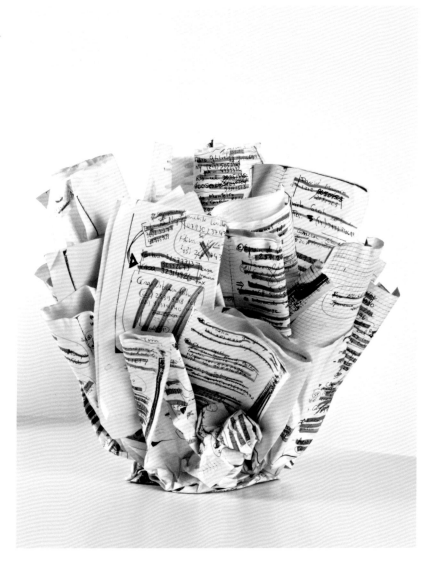

lost everything I made before that. It all disappeared somehow. I don't know where it is. I abandoned everything I was doing.

IB How old were you?

EV Not so young—I was twenty-seven. But I was very young in my thinking. I went there because I thought I was good, and I got a place, and I thought, it's going to be so cool after this, going to art school. I thought I was going to be a superhero, that I was good already. Then I looked at what I was doing and said, "Oh, this is not the thing. This is not what I want."

IB So you physically put away your old work?

EV It was a lot of paper. I have some of it somewhere. I don't like opening those files. One day I'll have to deal with it. It's a strange feeling. So I decided I wanted to be an artist; it was 1995, I was twenty-four, in São Paulo, taking summer courses with these artists. The scene was like a desert. There was nothing going on. Everything was so quiet.

IB What kind of artists were teaching?

EV They were what I call "The Eighties." People like Leda Catunda, who's a friend today, and I still look at her work a lot; and Carlito Carvalhosa, who's also a very important figure for me from the eighties. Painters, most of them. There was Sergio Romagnolo, who was Leda's husband. And he was a sculptor. I remember I took the sculpture class with him, and I would never be right; he didn't like anything I would do. Because I would be a bit literal and I would play with narrative, and they were very material-based. So I feel that today, I'm doing what I was supposed to do then; I'm a good student of his now.

IB You came around.

EV I agree with him now.

IB But you had to get there on your own.

EV It was a long way. The first sculptures were in 2003. Or a bit earlier, in 2001, when I made paper vases. The paper vase was me being reborn, after the two years at Goldsmiths, doing things too bad to show anyone.

IB And then you went back to São Paulo?

EV Home is São Paulo. Always has been. Sometimes I wish it was not. I always consider escaping, everywhere I go. I come to Saratoga and say, "Maybe that's it."

IB Is it important to have artists around you to visit and talk about what you're making?

EV No, that's a bit of a fantasy. I have some fantasies. Like having a studio is a fantasy. Because sometimes I say, "Oh, everything would be so different for me if I would just have a studio." But the artist scene, people don't talk about art in São Paulo. Maybe that's a Latin thing. We talk about the soap operas and relationships. We don't really talk about each other's work. Very little. You always have a small number of friends who you talk about art with. It's a marvelous thing when that expands to younger artists that you meet and click with.

IB When you made *Seven-Headed Monster* you invited other artists to collaborate.

EV That's probably one of those occasions that I went too far with the joke. It was a strange thing to do. I wrote to each one of them saying, "I don't know exactly what this is. Maybe you trust me." And so I created some safe rules for making a risky thing. The goal was to put on an exhibition in one sculpture.

IB An exhibition in one object.

EV Yeah. One sculpture, and part of the material of the sculpture would be artworks. Artworks as found objects.

IB And so you told all the artists what you were going to do?

EV I said, "We're all going to do this at the same time." I had made a sculpture called *The Seven-Headed Monster* in 2007, and I kind of kept making it. It had more than seven heads. I don't know exactly how I came to that, but it was kind of an apocalypse-y figure, with four paws and many heads. Each head would be made of fruits and vegetables, but composed so it would look like they had ears and noses, made out of vegetables. It actually started with a book for children, how to make your kids' food more interesting. And so I used that structure. It was very simple in the beginning.

IB What was your first bronze?

EV *Saramandaia* from 2006. That's the name of a soap opera. I chose this name because it's exotic. It would be like a sound for exotic. That's the first bronze. It's a vase. And where the flowers are, there would be sculpture clichés, like a bust and a bird, or me trying to represent sculpture clichés, coming out of the same pot. So when I invited the artists to participate in one sculpture, I was probably trying to do this again, like a monster containing every possible sculpture.

IB By making a monster it gives you permission to make different things that you want to make?

EV Yes.

IB But is it also symbolic of anything, this monster? Is it in any way a symbol of how you're feeling about yourself or the world?

EV No. It's more me trying to exorcise or accommodate my own anxiety about all the possibilities that exist in art making. I don't see myself so much as a monster.

IB Bodies are in a lot of your work.

EV Are they?

IB You don't think so?

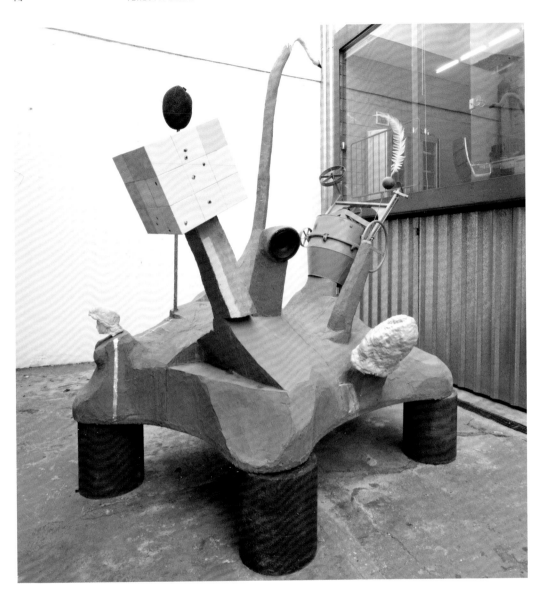

(above and details facing)

*Bicho de 7 Cabeças/ 7
Headed Monster*, 2010
In collaboration with
Adriana Varejão, Alexandre
da Cunha, Damián
Ortega, Efrain Almeida,
Carlos Bevilacqua &
Ernesto Neto, Jac Leirner
and Nuno Ramos
Mixed media
159¾ x 86⅝ x 122 inches

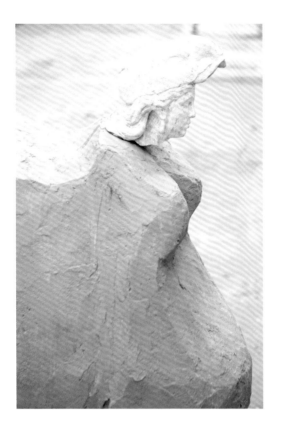 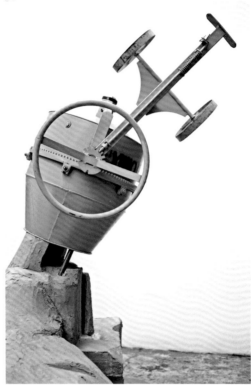

EV No, I think that I'm so bad with the human body. That's something that I just can't make. I'm bad at it, so I keep trying.

IB There are bodies in here: round things, holes, appendages, heads, ears....

EV I'm trying to disguise it. I'm trying to find my way to the body from the edges. There are lots of edges and outlines in the sculptures. With the *Missionary* sculptures for example, there are a lot of outlines. Because I deal with things as images, I have a favorite point of view for sculptures—*Mineral* is a super-frontal thing.

IB What about the mannequin bodies in your video *It's So Hard*? Are those photographs from store window displays?

EV They are all online. I didn't photograph them; I found the photographs. They vary in a crazy way. I had a lot of fun with that. I wish I could do more stuff with this, but I cannot. They are too good all by themselves.

IB What attracted you to these?

EV I don't know—this Brazilian bikini butt image. Also hot pants. That's an image that's in me forever—maybe it's a cultural thing. I just find them

beautiful—you know?—making a drawing of this bikini from behind. I have created instructions to do it: one curve, another curve, a diamond in the center. I'm always curious when I see sculptures of butts. Rebecca Warren did one and I was like, "Ooh, she got it." Because it's all round, like a ball with a mark, just a groove in the middle. It's an entire ball. I said, "Ooh, that was smart." Because I don't know where to end— where to cut the body on top.

IB But when you say you have been carrying around this thing about the Brazilian butt, is that a celebration or a burden?

EV I don't have a problem celebrating it. I always marveled, since I was a child, at women's bodies. And the way it was exploited in advertising, all the stretch jeans, I remember very well in the eighties—that was super-erotic. It's very much for the erotic appeal, so it's easy for me to connect this to the work I'm doing now. It's very tactile.

IB When you're making sculpture that isn't so specific to a body, is there an erotic edge for those, too?

EV Probably. There are fingers everywhere. You have the indication: fingers were here. For me, that's a desperate need to share the experience, in that case, of the clay—the contact with the clay: wet, smooth, firm, cold and so on. They are sensual.

IB Was it meant to capture the immediacy you feel? And try to hold that, so that you can show other people?

EV Yeah. Yeah.

IB Do you like people recognizing things in your work, like a tray of makeup in *Call Girl*?

EV Well, I like titles. I'm never untitled.

IB Your titles are great.

EV Thanks. I think the artist should title things and then shut up. I don't

like instructions of how to look at a work. So if people didn't see makeup there, maybe I would be a bit anxious, because that's a very funny one. But it's almost as if the makeup is not really there. That's not makeup. That's not an image of makeup; that's something else. Like this geometry, that is handmade, and that doesn't really fit.

IB How did you come up with the title *Painted Lady*?

EV I called that sculpture a woman, because I really wanted it to have breasts and hips,

IB Or *Tortoise*? The word is funny.

EV Yeah, the word is hilarious. I can barely pronounce it!

IB Do you like your titles to be translated?

EV It depends. I see them piece-by-piece, each way.

IB Do you think of them in one language?

EV One language. It could be Portuguese or English. Many times it's English. I don't think in Portuguese and then translate to English.

IB How do you choose which vegetables to use for molds?

EV That was the early days. I had many molds of vegetables, and I chose them for their texture.

IB What makes them good?

EV I never made an apple because it's too smooth. The outline is not really definite.

IB So you like texture?

EV Or outlines.

IB Or holes?

EV With fruits it was more about skin and protuberances. In the wall works,

holes are starting to play an interesting new game. Not complete orifices as in Barbara Hepworth, not just yet. But depressions and craters.

IB Talk about *Mineral*, the main work in our exhibition.

EV I started painting clay, trying to make it look like amethyst. Then I used bits of the real stone. And then I went back to faking it, because the geodes were too good, or too real. But what I like a lot is that in the final work, we have the fakes, and the realistic castings, and hand made geodes, and clay pedestals...none of the experiences were left out, they were all integrated to create some liberal new nature with contradictory rules.

IB Why did you start using geodes? Where did you see them?

EV I've seen them all my life.

IB Did you have a collection?

EV No. I hated them! They were the ugliest things possible. Nobody liked them, really. Now they're everywhere. Now, like everybody else, I feel they're beautiful. I got that *wave* of the stones and geodes, one year before I started seeing them everywhere.

IB So when you started being interested in them, you were investigating something that you thought was ugly? Or something you were attracted to because it was a bit of an attraction-repulsion at the same time?

EV No, I felt attracted to them after a lifetime of not liking them. And this happens all the time. We need to see things that our eyes are not tired of. I feel easy about the need for novelty, I see it as some human basic need for expansion. We like something, and then we don't like it anymore because we've had too much. Then we want something new until we feel uninterested again.

IB Yeah, you're too full.

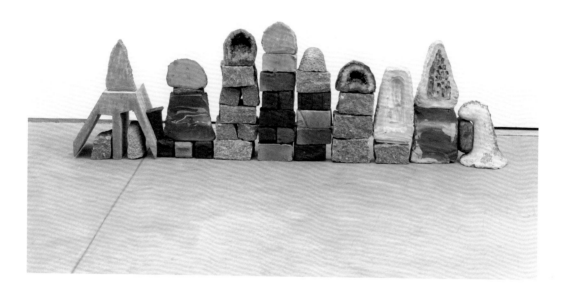

Murundum/Stone Cemetery, 2013
Cobblestones, clay, concrete and stones
33½ x 90½ x 15¾ inches

EV Yeah. Proust talks about that in a beautiful way. A very beautiful way. He tells the story of this opera that he went to see, *Phaedra*. Then, maybe two, four, five years after that, he goes back, with all that expectation of revisiting the memory he had, and that singer he loved, the woman's hair, all these details. And then he goes again through all the details and talks about how much he's not enjoying them now. He's sitting there and saying, "Oh, my God, I'm not enjoying her dress. I'm so sad that I'm not enjoying this. What's happening to me?" And that includes love, people, and literature. It's beautiful.

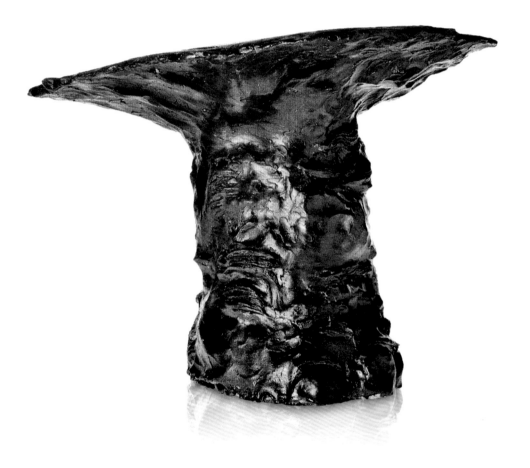

Bronze, 2003
Painted unfired clay
10¼ x 14⅛ x 15 inches

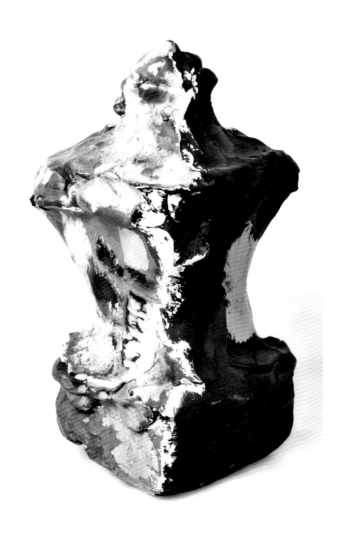

Bombom, 2004
Painted unfired clay
9¾ x 4 x 4⅜ inches

(facing)

Rabisco/Scribble, 2007
Bronze and cold
porcelain clay
18⅛ x 14¼ x 10¼ inches

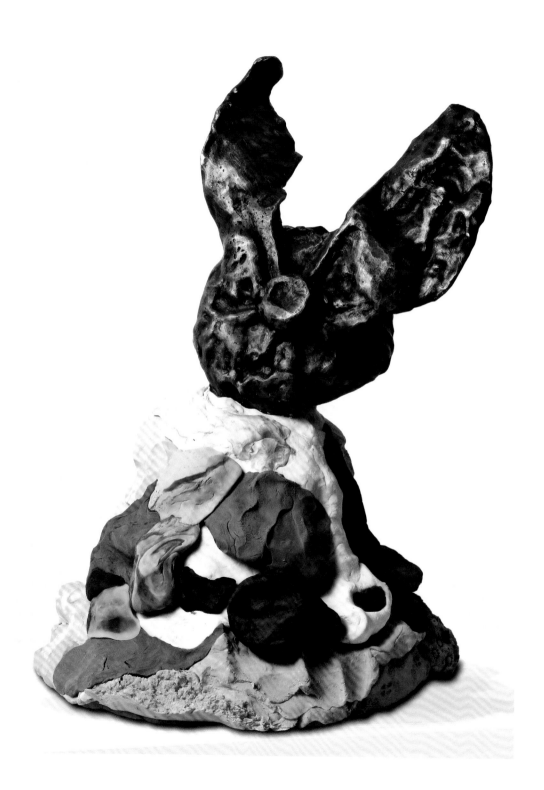

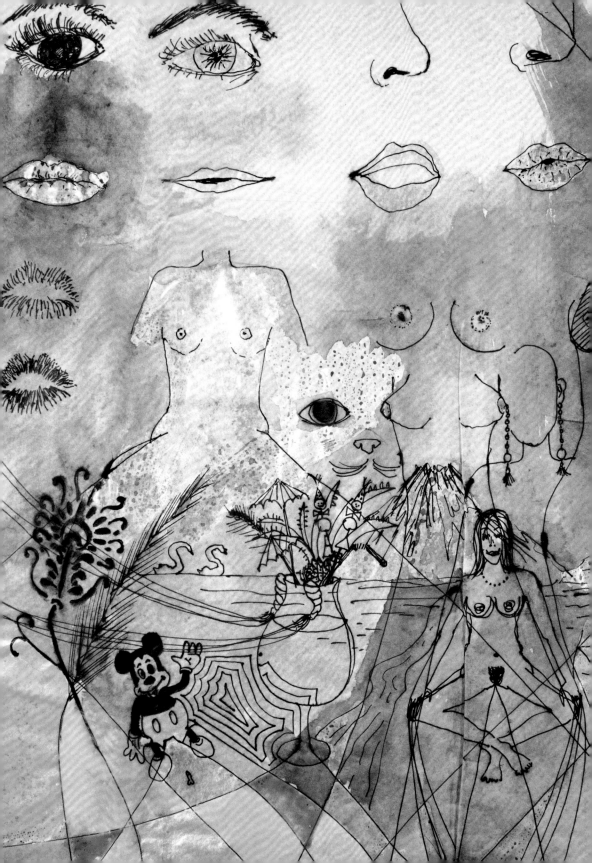

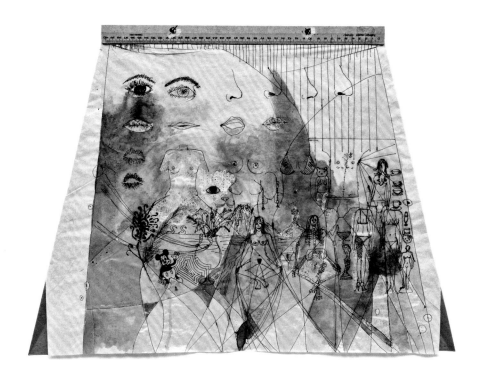

(above and detail facing)

Aluna/Student, 2006
Pen and acrylic on
paper and ruler
18½ x 25⅛ inches

Saramandaia, 2006
Bronze
18⅞ x 14¼ x 17¾ inches

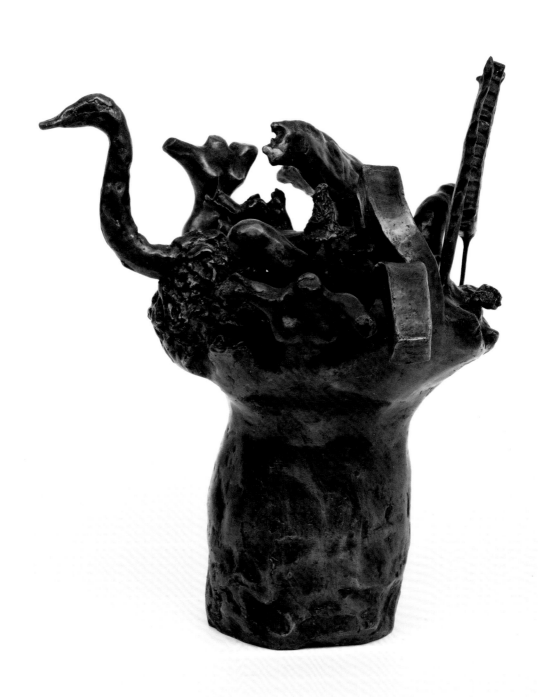

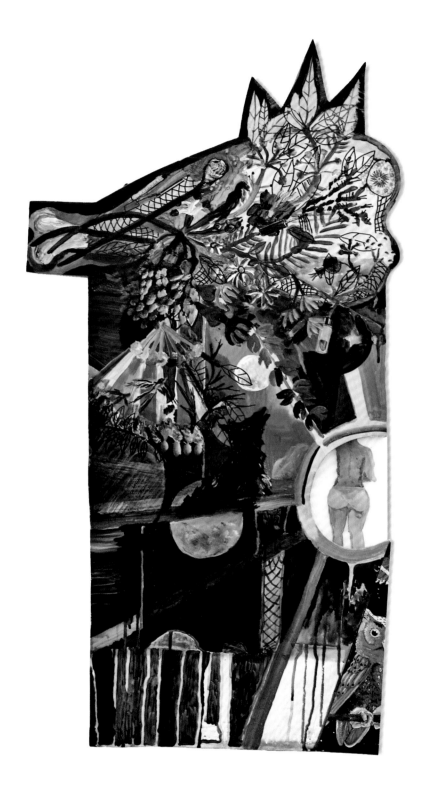

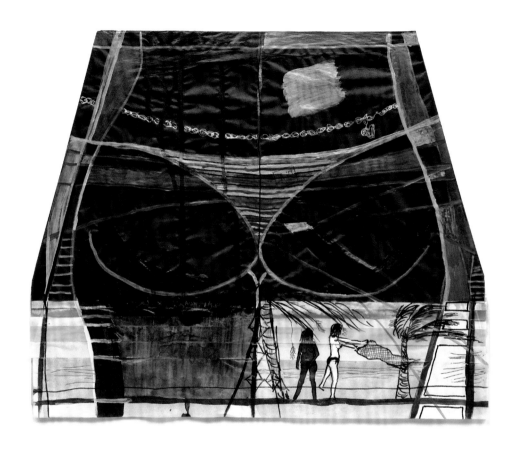

(facing)

Loba/She Wolf, 2006
Acrylic on mdf, cardboard
and glass
37⅜ x 20 inches

Black, 2006
Acrylic on paper
16⅛ x 19⅝ inches

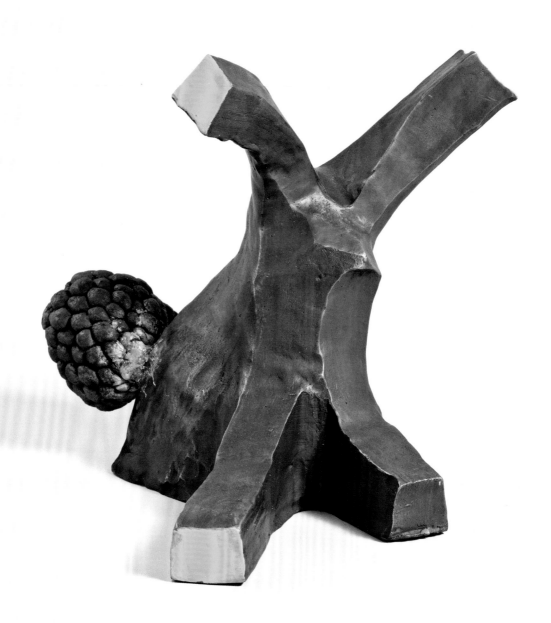

Henry, 2008
Bronze and acrylic
12⅝ x 14½ x 15¾ inches

Jaspera, 2006-2008
Bronze and acrylic
21⅝ x 9⅞ x 9⅞ inches

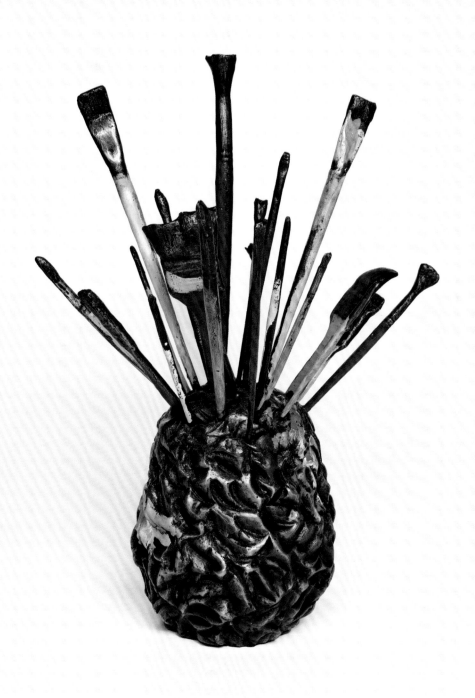

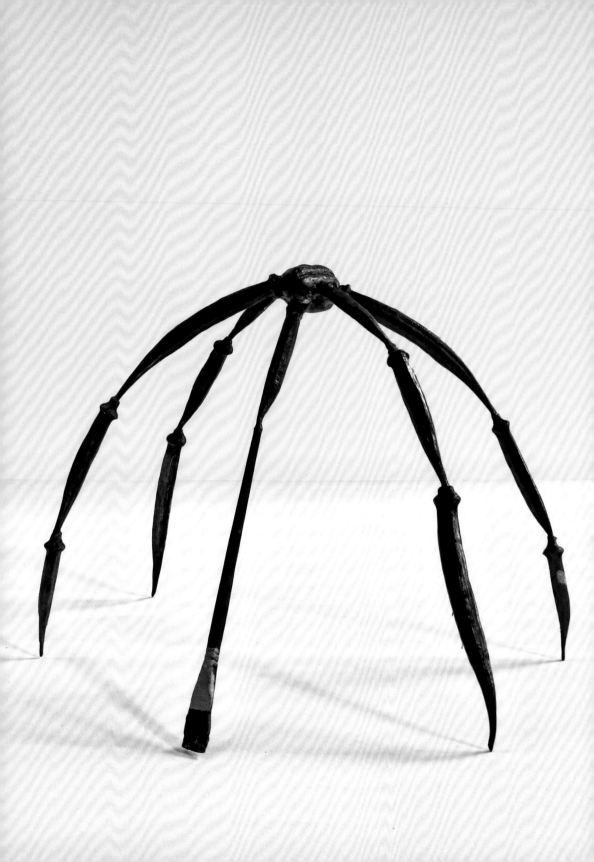

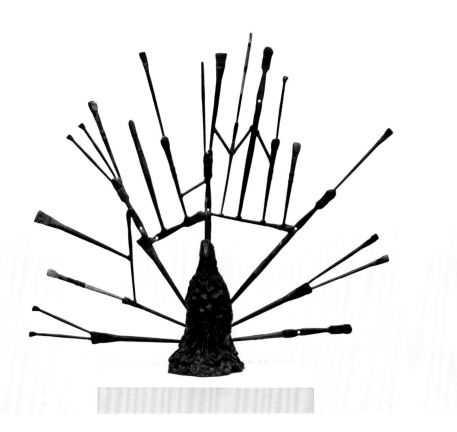

(facing)

Desenho/Drawing, 2011
Bronze and acrylic
12⅝ x 17⅓ x 12¼ inches

Pavão/Peacock, 2008
Bronze and acrylic
35⅜ x 39⅜ x 9½ inches

*Bicho de 7 Cabeças/ 7
Headed Monster*, 2008
Bronze and cold
porcelain clay
56¼ x 61 x 42⅛ inches

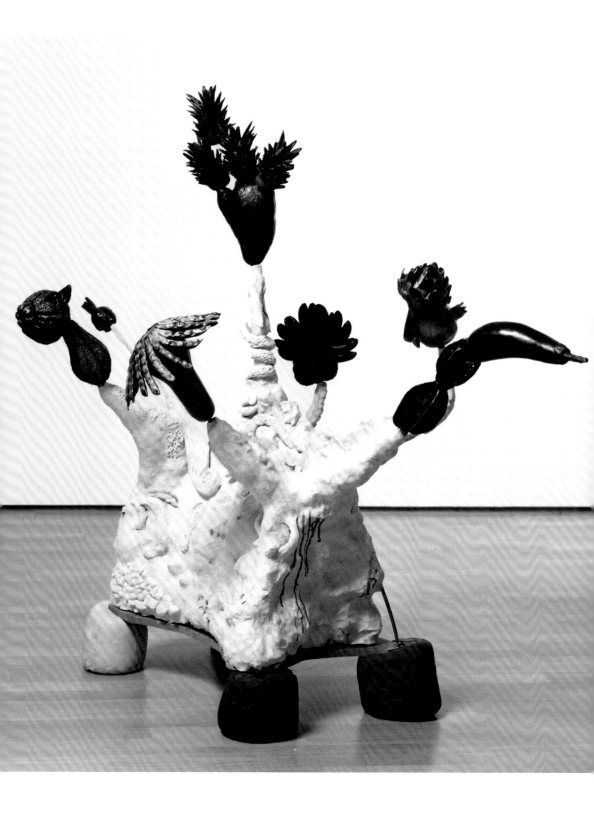

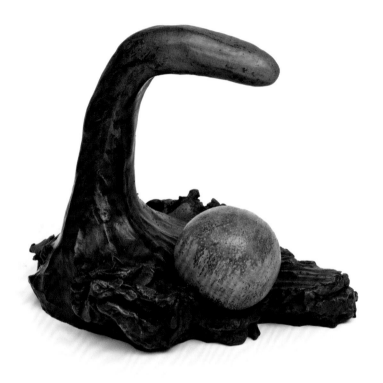

Tarsila com Laranja/
Tarsila with Orange, 2011
Bronze and acrylic
10⅝ x 10⅝ x 12⅛ inches

(facing)

Missionary, 2011
Bronze and Acrylic
12⅛ x 3⅞ x 6⅜ inches

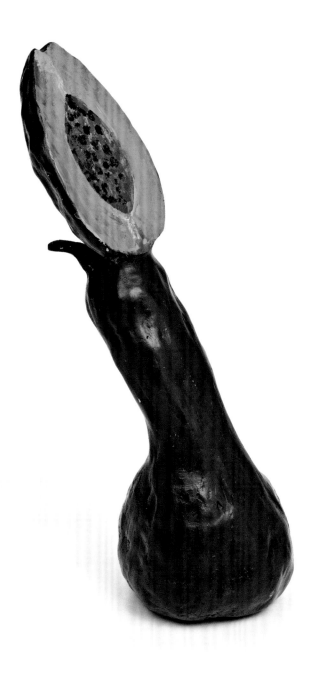

Egg Carton, 2012
Concrete, bronze,
synthetic clay and wax
10 x 9¼ x 9 inches

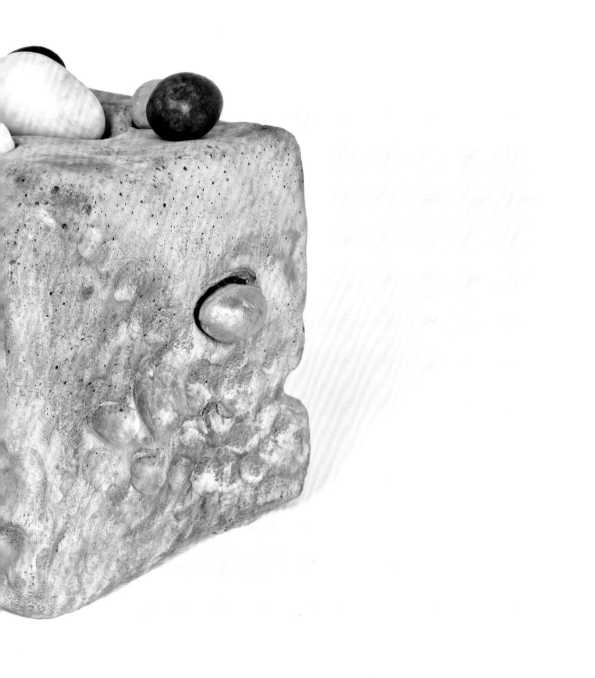

Egg Tower, 2013
Bronze, egg shell,
concrete and wax
110¼ x 15¾ x 15¾ inches

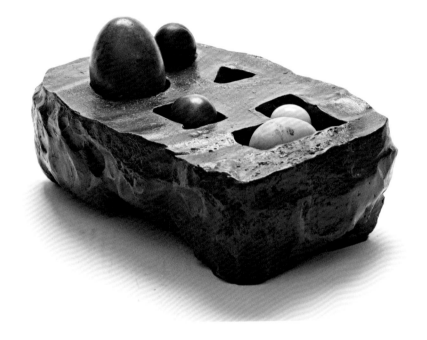

Monkey Box, 2013
Bronze
3 x 8¼ x 4¼ inches

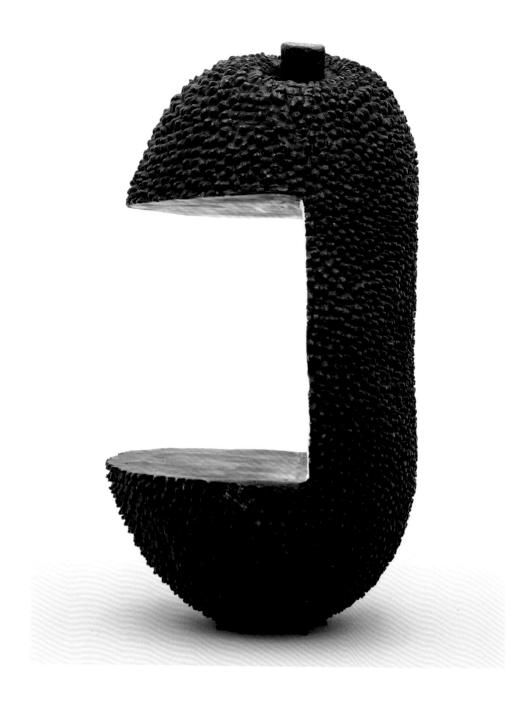

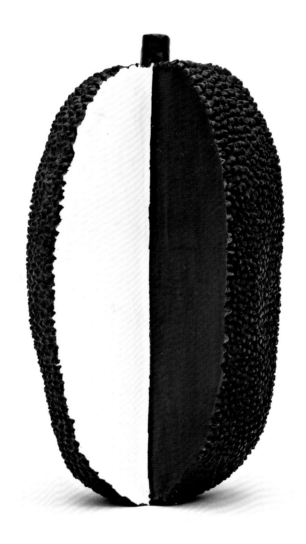

(facing)

Brasília TV, 2011
Bronze and acrylic
118⅞ x 8¼ x 6¾ inches

Brasília, 2010
Bronze and acrylic
11¾ x 7⅛ x 7⅛ inches

Venus on Fire, 2013
Bronze
55⅛ × 24¾ × 24¾ inches
Solomon R. Guggenheim
Museum, New York,
Guggenheim UBS MAP
Purchase Fund 2014.54

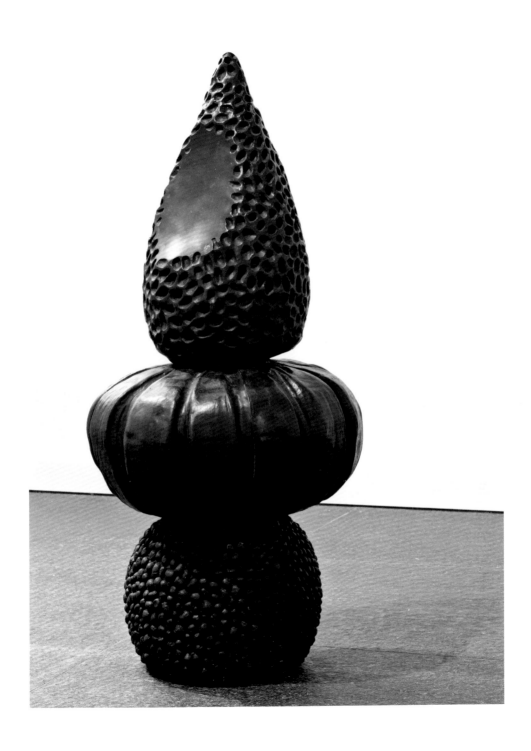

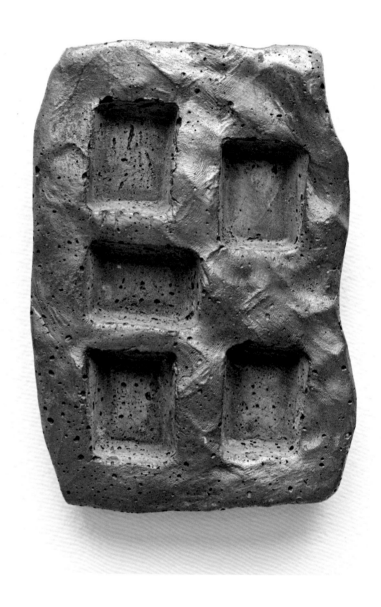

Small Golden Book, 2013
Concrete and wax
6⅝ x 5⅛ x 1⅛ inches

(facing)

Textbook, 2013
Bronze
13 x 8¼ x 2 inches

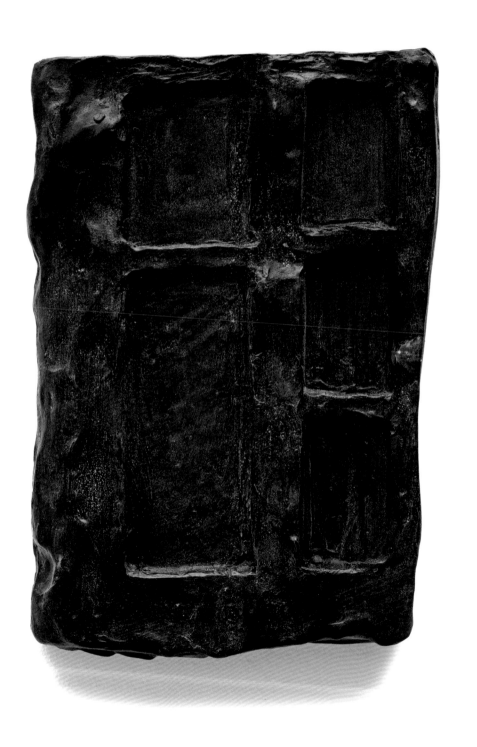

Call Girl, 2013
Bronze and cold
porcelain
6⅝ x 4⅞ x 1½ inches

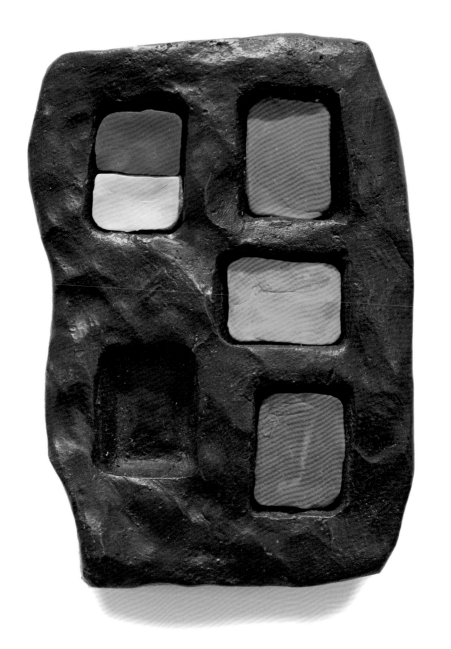

Lua Ovo/Egg Moon, 2013
concrete, wax, styrofoam
and cold porcelain
10¼ x 7½ x 1½ inches

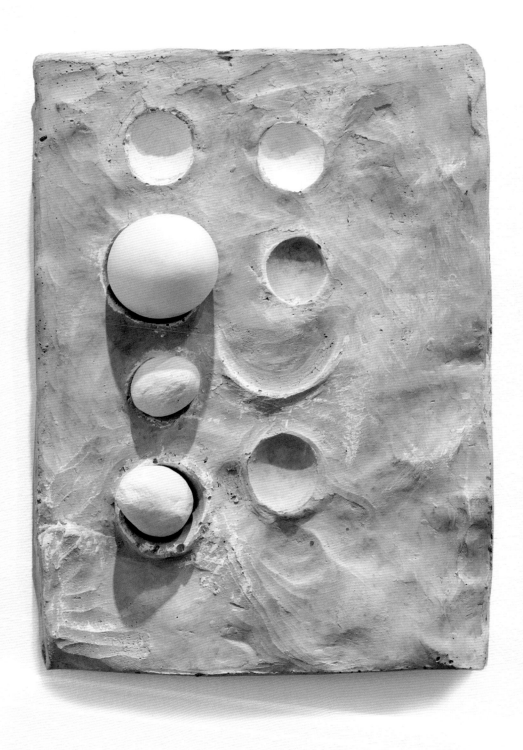

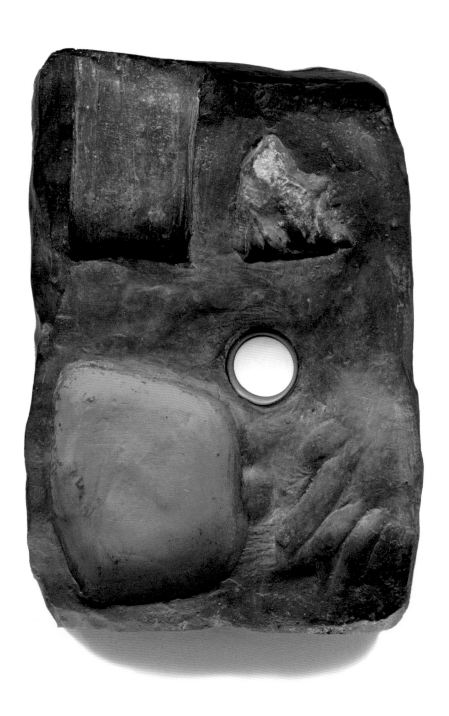

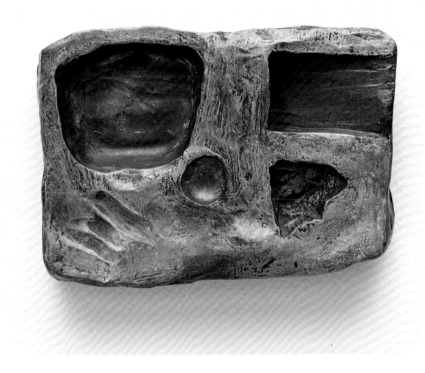

(facing)

Girl with a Pearl Earring,
2013
Bronze, acrylic, wax
and stone
8¼ x 6 x 1½ inches
Solomon R. Guggenheim
Museum, New York,
Gift of the artist on the
occasion of the
Guggenheim UBS MAP
Global Art Initiative
2014.63

Pink Photo Frame, 2013
Bronze and wax
6 x 8¼ x 1½ inches

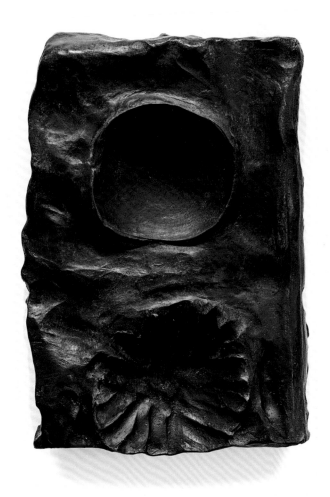

Flor/Flower, 2013
Bronze
13⅜ x 8⅝ x 1½ inches

(facing)

Gerbera, 2013
Concrete and wax
13⅜ x 8⅝ x 1½ inches

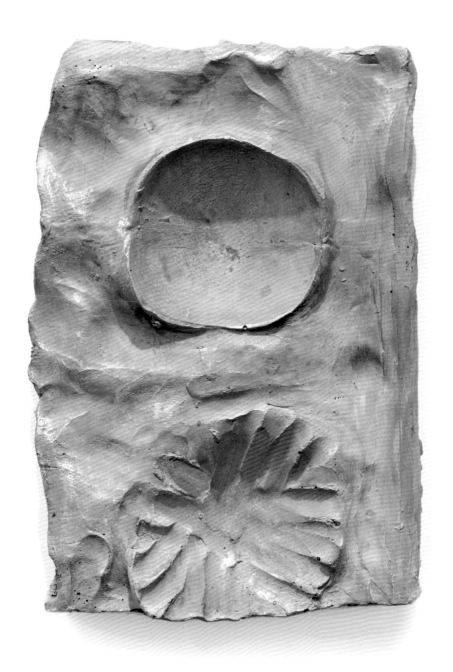

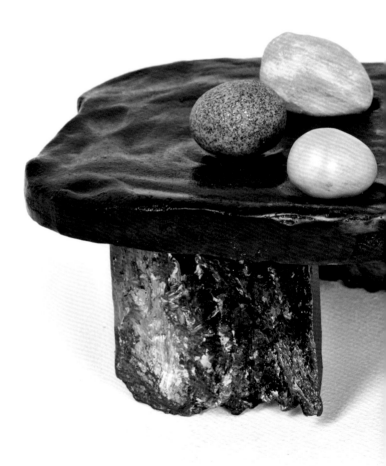

Tortoise, 2012
Bronze, natural clay,
synthetic clay, acrylic
and wax
5⅛ x 9 x 13¾ inches

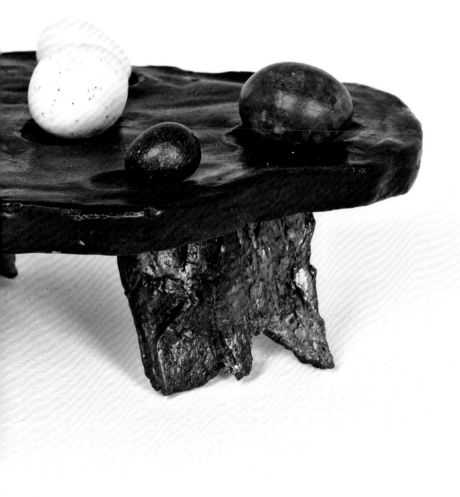

Big Golden Book, 2013
Concrete and wax
18⅞ x 13¾ x 1½ inches

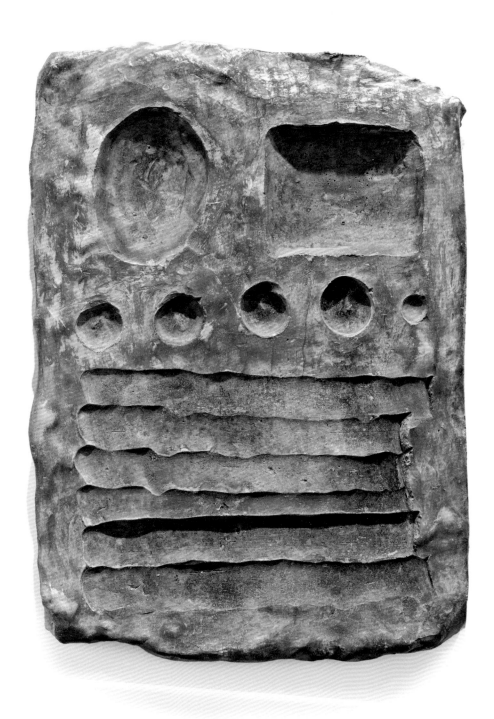

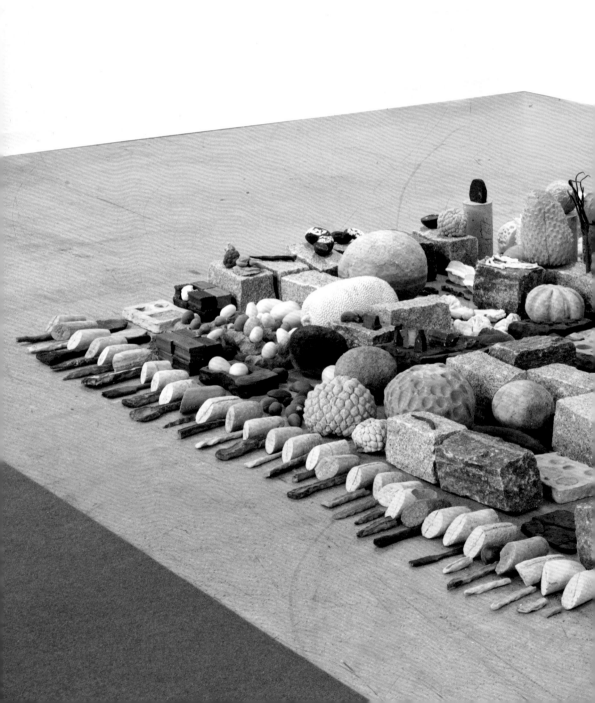

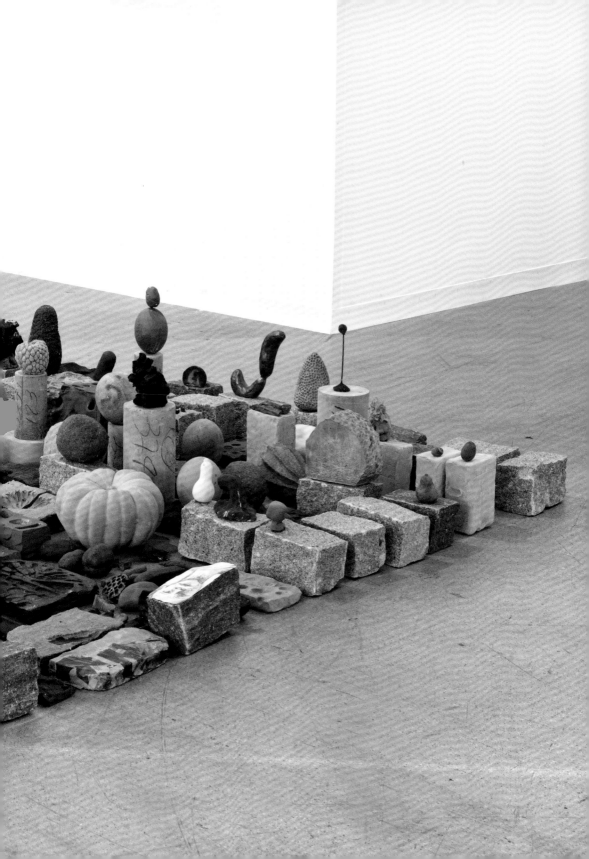

(previous spread)

*Cemitério com Franja/
Fringe Cemetery*, 2014
Studio remains, drawings
and cobblestones
11¾ x 86½ x 94½ inches

(facing)

Cocar / Cockade, 2014
Bronze
39⅜ x 31½ x 6⅜ inches

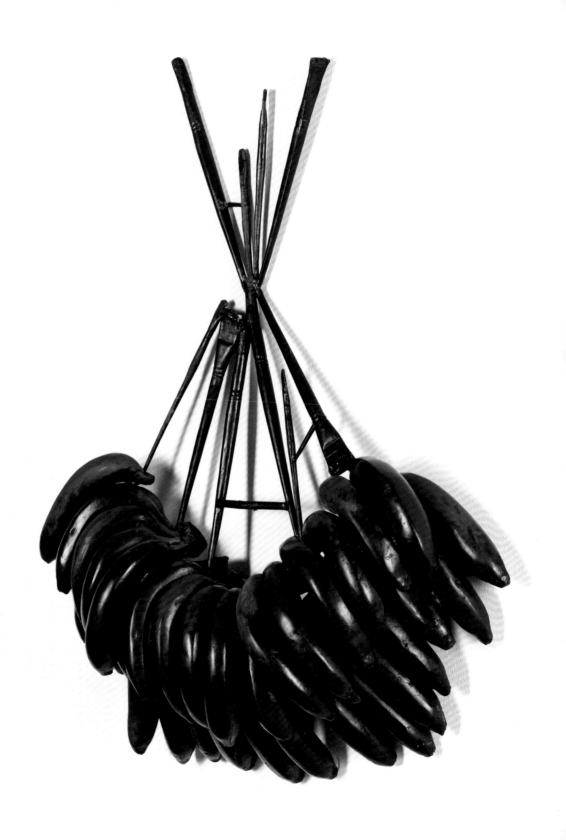

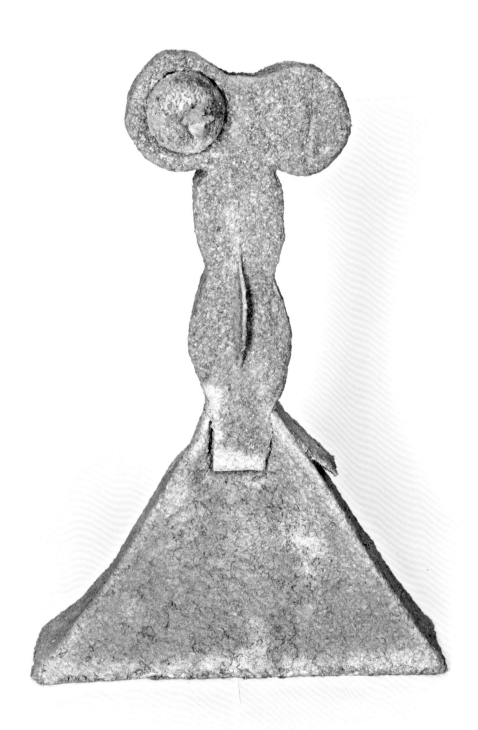

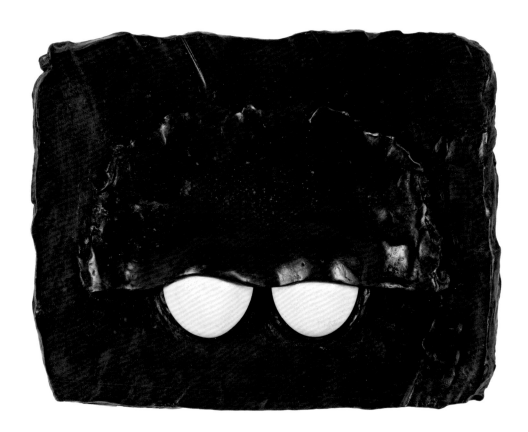

(facing)

The Painted Lady, 2014
Papier-mâché, wax
and acrylic
42½ x 29⅛ x 9⅛ inches

Boyfriend, 2014
Bronze and ostrich egg
shells
24 x 19⅝ x 5½ inches

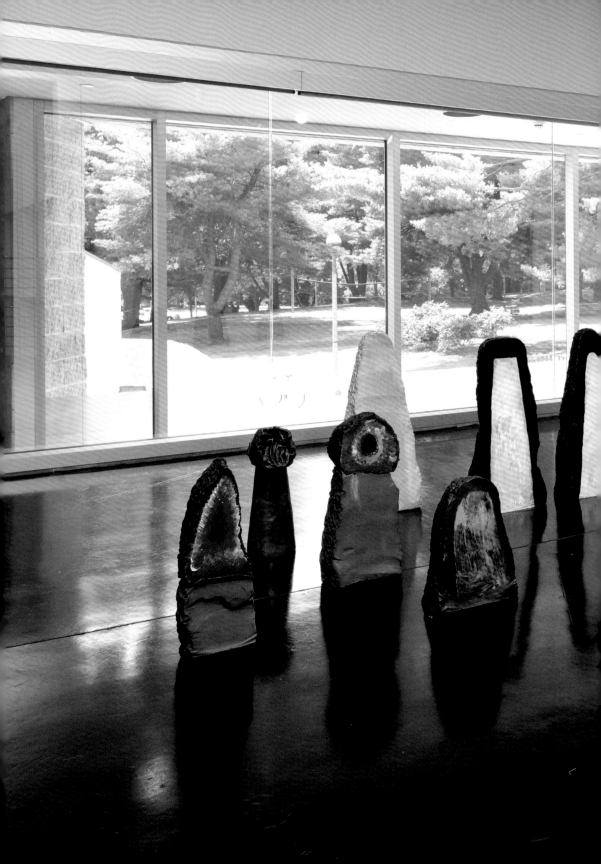

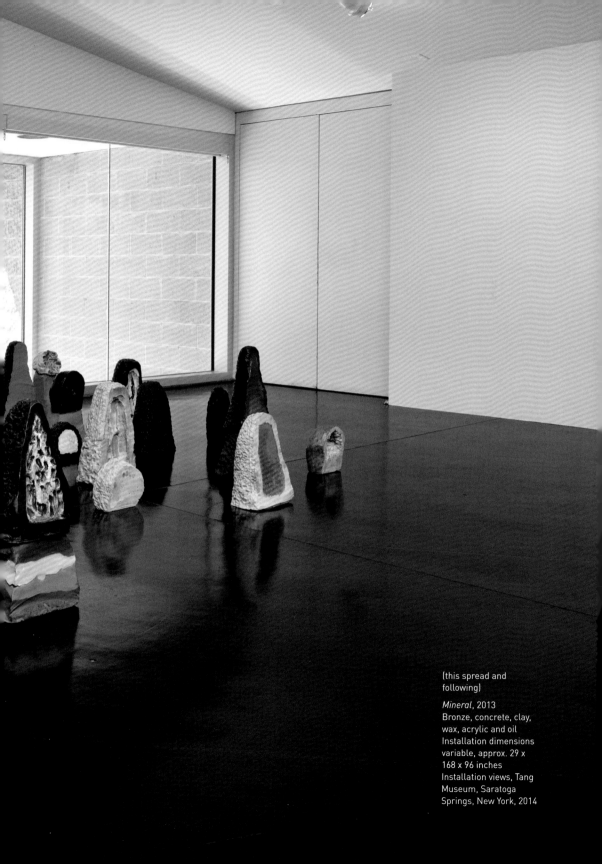

(this spread and following)

Mineral, 2013
Bronze, concrete, clay,
wax, acrylic and oil
Installation dimensions
variable, approx. 29 x
168 x 96 inches
Installation views, Tang
Museum, Saratoga
Springs, New York, 2014

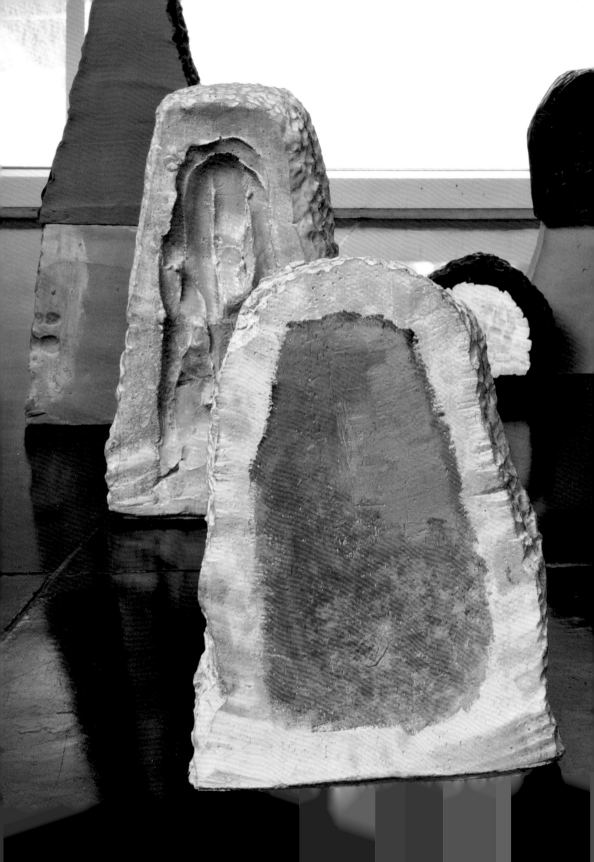

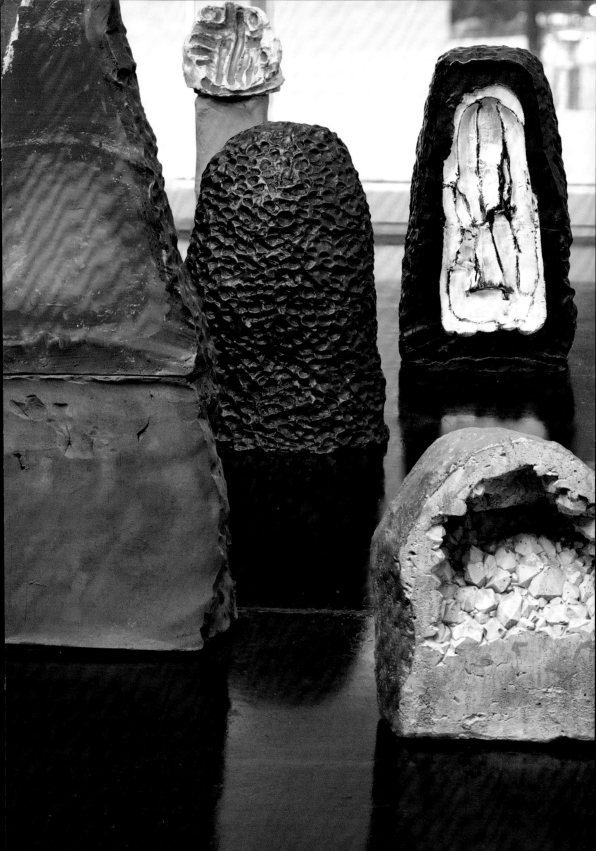

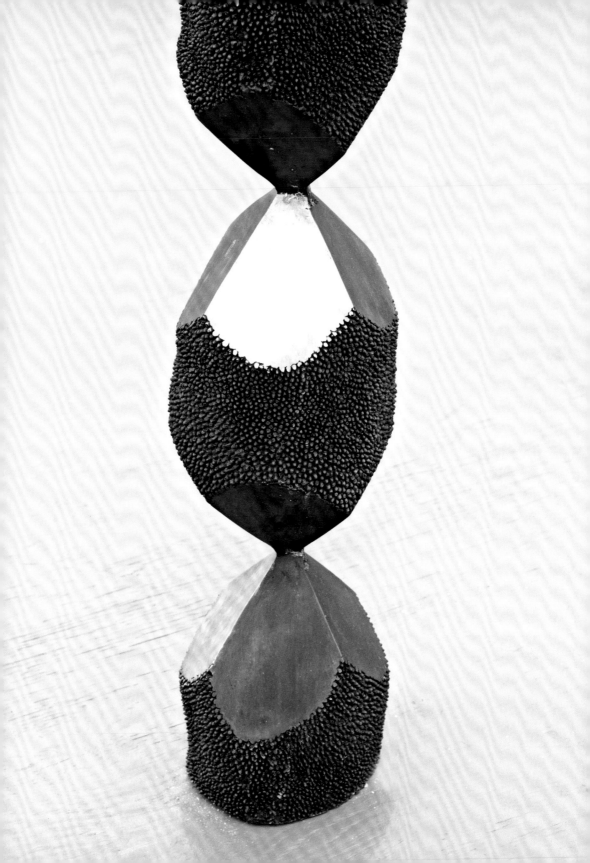

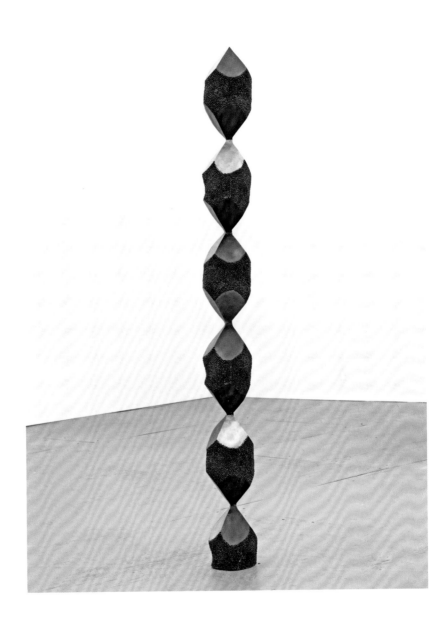

(above and detail facing)

Lápis, 2014
Bronze and wax
112⅛ x 7⅞ x 7 inches

(facing, left to right)

Antena / Antenna, 2014
Bronze
76 x 7 x 6¼ inches

Swan with Hammer, 2013
Bronze and sledgehammer
25½ x 27½ x 27½ inches
Carnegie International,
A. W. Mellon
Acquisition Fund
Installation view, *Painted
Ladies*, Galerie Peter
Kilchmann, Zurich,
Switzerland, 2014

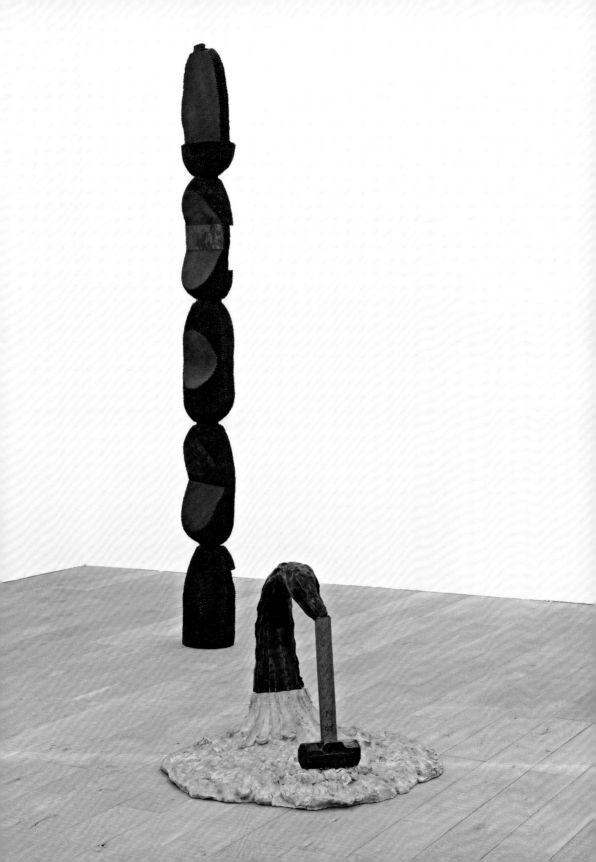

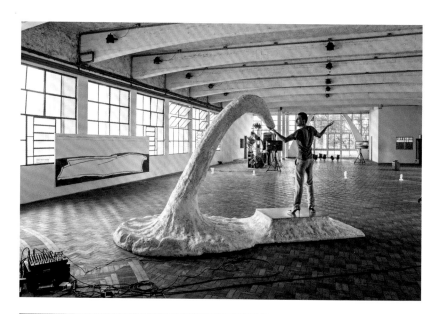

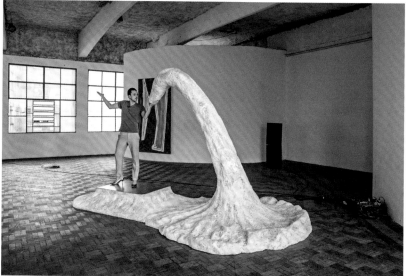

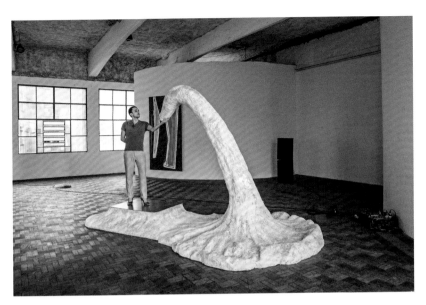

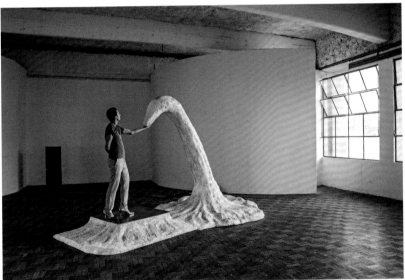

(this spread and following)

*Cisne com Palco /
Swan with Stage*, 2014
Styrofoam, iron,
papier-mâché, fiberglass
and acrylic
114⅛ x 176⅜ x 99⅝ inches
Performance view with
actor Vinicius Massucato,
Postcodes, Casa do Povo,
São Paulo, 2014

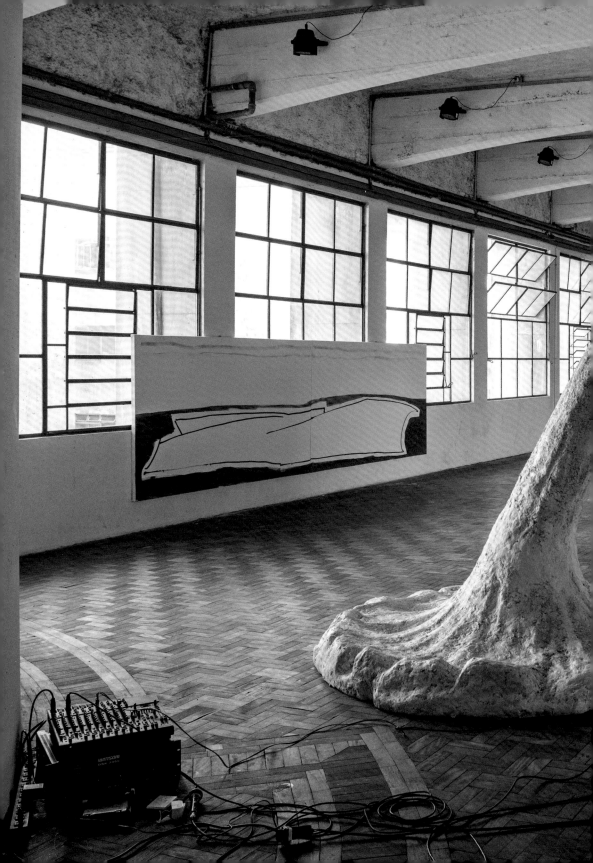

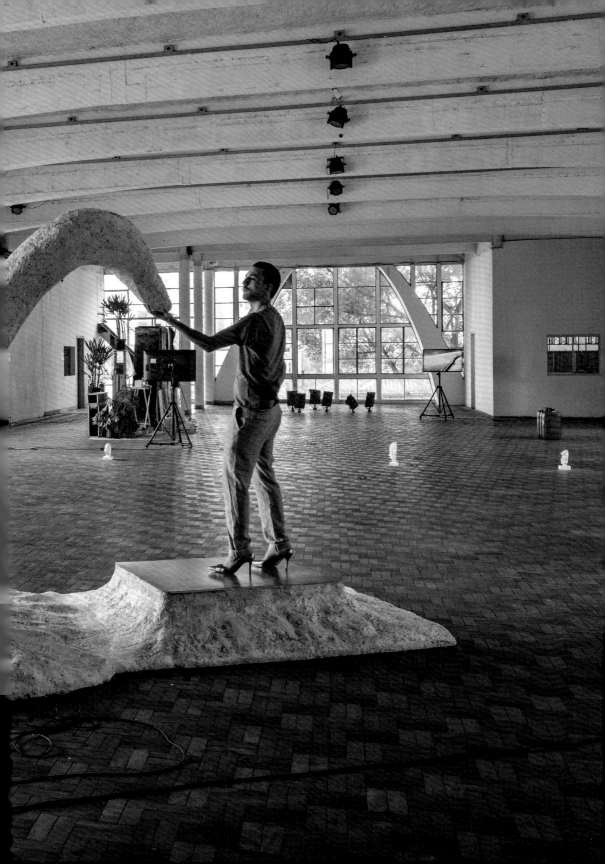

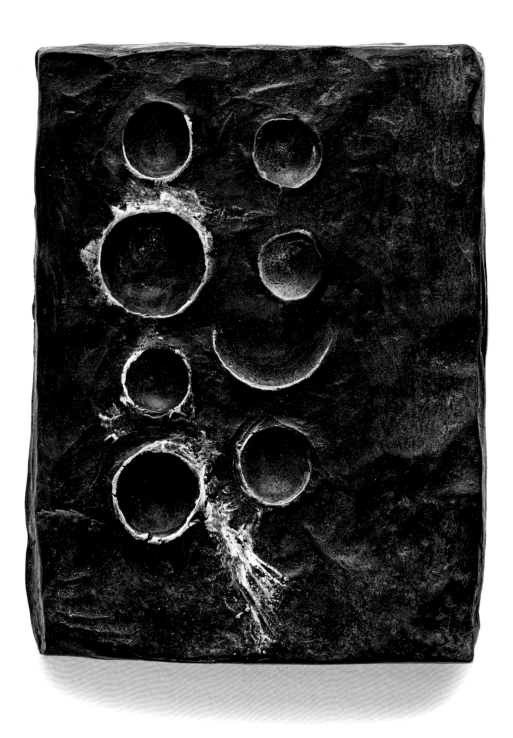

CHECKLIST

All works by
Erika Verzutti

Dimensions listed in inches
height x width x depth

All works courtesy of the
artist and Galeria Fortes Vilaça,
São Paulo.

1
The Book of Gems, 2013
Concrete and wax
11½ x 9 x 2

2
Call Girl, 2013
Bronze and cold porcelain
6⅝ x 4⅞ x 1½
Collection of Rodrigo
Ferreira da Rocha

3
Incrustado, 2013
Bronze and stones
11½ x 8¼ x 2⅛

4
Jaws, 2013
Concrete and wax
13⅝ x 9½ x 2⅜

5
Lua/Moon, 2013
Bronze and wax
10 x 7¾ x 2

6
Mineral, 2013
Bronze, clay, concrete, wax,
acrylic and oil
Installation dimensions
variable, approx. 29 x 168 x 96

(facing)

Lua/Moon, 2013
Bronze and wax
10 x 7¾ x 2 inches

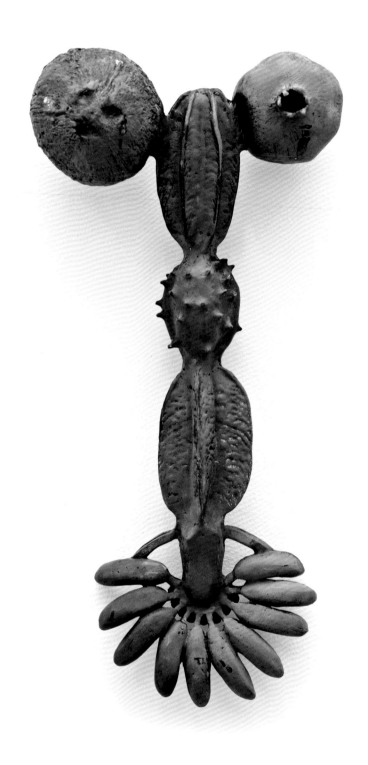

ERIKA VERZUTTI

BORN IN SÃO PAULO,
BRAZIL, IN 1971

LIVES AND WORKS IN
SÃO PAULO, BRAZIL

EDUCATION

2000
Associate Research Student,
Fine Arts, Goldsmiths
College, London, United
Kingdom

1999
Postgraduate Diploma, Fine
Arts, Goldsmiths College,
London, United Kingdom

1991
Graduate in Industrial Design,
Universidade Mackenzie, São
Paulo, Brazil

SOLO EXHIBITIONS

2014
Opener 28 Erika Verzutti:
Mineral, Frances Young Tang
Teaching Museum and Art
Gallery at Skidmore College,
Saratoga Springs, New York,
July 5–November 16

Painted Ladies, Galerie Peter
Kilchmann, Zürich, Switzer-
land, June 14–July 19

2013
Palettes, Misako & Rosen,
Tokyo, Japan, October 20–
November 17

2011
Missionary, Galpão Fortes
Vilaça, São Paulo, Brazil, May
14–July 16

2010
Bicho de 7 Cabeças [Seven-
Headed Monster], Galpão
Fortes Vilaça, São Paulo,
Brazil, September 19–January
14, 2011

AIT Backers Residency
Exhibition, Side 2 Gallery,
Tokyo, Japan, May 22–June 12

Chopping Board, Misako &
Rosen, Tokyo, Japan, April
18–May 23

2009
Erika Verzutti, Swallow Street,
London, United Kingdom,
September 4–October 3

2008
Pet Cemetery, Galpão Fortes
Vilaça, São Paulo, Brazil,
October 11–December 13

2007
Bicho de 7 Cabeças [Seven-
Headed Monster], Blow
de la Barra, London, United
Kingdom, October 8–
November 10

2006
À Sombra das Raparigas em
Flor [In the Shadow of Young
Girls in Flower], Galeria
Fortes Vilaça, São Paulo,
Brazil, May 4–May 27

2003
Sculptures, Galeria Fortes
Vilaça, São Paulo, Brazil, July
8–August 8

1997
Meditation Platform, Centro
Cultural da Universidade
Federal de Minas Gerais, Belo
Horizonte, Brazil, October
30–November 16

1995
Itaú Cultural Institute, São
Paulo, Brazil

Exhibitions Program, Centro
Cultural São Paulo, São
Paulo, Brazil, April 12–May 7

GROUP EXHIBITIONS

2014
Histórias Mestiças, Instituto
Tomie Ohtake, São Paulo,
August 16—October 5

Under the Same Sun: Art from
Latin America Today, Solomon
R. Guggenheim Museum,
New York, USA, June 13–
October 1

Alimentário: Arte e Construção
do Patrimônio Alimentar
Brasileiro [Alimentary: Art
and Architecture of the
Brazilian Food Heritage],
Museu de Arte Moderna do
Rio de Janeiro, Rio de
Janeiro, Brazil, June 12—
August 10

(facing)

Painted Lady, 2011
Bronze and acrylic
8 3/8 x 3 7/8 x 1 7/8 inches

Installation view,
Pet Cemetery, Galpão
Fortes Vilaça, São Paulo,
Brazil, 2008

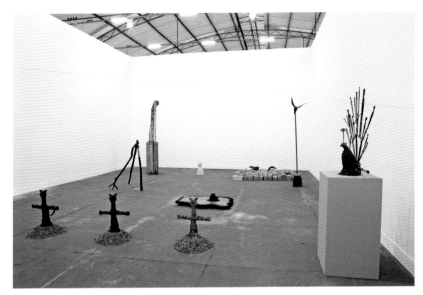

Matriz e Desconstrução, Anita
Schwartz Galeria, Rio de
Janeiro, Brazil, May 16—July 5

Postcodes, Casa do Povo, São
Paulo, Brazil, May 8–May 31

Salon Distingué, Museum
Langmatt, Baden, Switzerland,
May 3–November 30

Banana Boat, Álvaro Razuk
Arquitetura, São Paulo,
Brazil, April 6

*Cruzamentos: Contemporary
Art in Brazil*, Wexner Center
for the Arts, Ohio, February
1–April 20

140 Caracteres, Museu de Arte
Moderna de São Paulo, São
Paulo, Brazil, January 28–
March 26

Matter & Memory, Alison
Jacques Gallery, London,
United Kingdom, January 16–
February 15

2013
Sobrenatural, Estação
Pinacoteca, São Paulo, Brazil,
November 30–March 9, 2014

56th Carnegie International,
Carnegie Museum of Art,
Pittsburgh, Pennsylvania,
October 5–March 16, 2014

Voir est une Fable, Chambres
à Part, Paris, France, October
21–October 27

Se o clima for favorável
[Portals, Forecasts and
Monotypes], Mercosul
Biennial, Porto Alegre, Brazil,
September 13–November 11

*Vision of Paradise: The Savage
Mind*, Art Rio, Rio de Janeiro,
Brazil, September 5–
September 8

Betão a Vista, MuBE, São
Paulo, Brazil, August 2–
August 18

*Universo Bordallo Pinheiro: 20
Bordallianos Brasileiros*, Oi
Futuro, Rio de Janeiro, Brazil,
July 23–September 8

Mitologias por Procuração,
MAM - Museu de Arte
Moderna da São Paulo, São
Paulo, Brazil, July 12–
September 15

Commercial Break, Anony-
mous Gallery, Mexico City,
Mexico, April 9–May 25

2012
*Coleção BGA – Brazil Golden
Art*, MuBE, São Paulo, Brazil,
December 14–December 27

Principios Flexor, Galeria
Gramatura, São Paulo, Brazil,
September 5–October 6

Installation view,
Missionary, Galpão
Fortes Vilaça, São Paulo,
Brazil, 2011

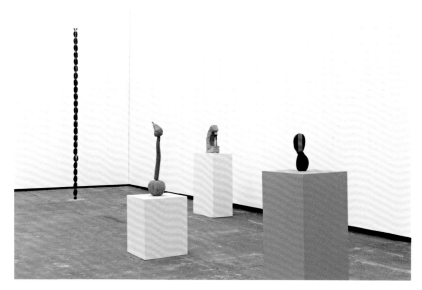

Armin Boehm, Fabian Marti, Erika Verzutti – I Give the Name Violence to a Boldness Lying Idle and Enamored of Danger (Jean Genet), Galerie Peter Kilchmann, Zurich, Switzerland, August 31–October 20

Home Again – 10 Artists Who Have Experienced Japan, Hara Museum of Contemporary Art, Tokyo, Japan, August 28–November 18

Lilliput, High Line Art, New York, April 19–April 14, 2013

Air de Lyon, Fundación PROA, Buenos Aires, Argentina, March 17–June 24

Antonio Malta & Erika Verzutti, Centro Cultural São Paulo, Brazil, March 10–May 27

2011
Tropico Abierto, Gran Bienal Tropical, San Juan, Puerto Rico, December 10

Mythologies, Cité Internationale des Arts, Paris, France, December 7–December 21

New Brazilian Sculpture – Heritage and Diversity, Caixa Cultural Rio de Janeiro, Rio de Janeiro, Brazil, November 14–January 1, 2012

A Terrible Beauty is Born, 11th Biennale de Lyon, Lyon, France, September 15–December 31

2010
Law of the Jungle, Lehmann Maupin Gallery, New York, December 10–January 29, 2011

BigMinis: Fetishes of Crisis, Musée d'Art Contemporain de Bordeaux, France, November 18–February 27, 2011

Primeira e última, notas sobre o monumento, Galeria Luisa Strina, São Paulo, Brazil, September 20–December 17

Use & Mention, Stephen Lawrence Gallery, University of Greenwich, London, United Kingdom, January 26–February 26

2009
Paper Moon, Sommer & Kohl, Berlin, Germany, October 31–December 19

Studio Voltaire, BolteLang, Zürich, Switzerland, October 31–December 19

Alcova, Galeria Laura Marsiaj, Rio de Janeiro, Brazil, July 8–August 9

Era uma vez... arte conta histórias do mundo [Once Upon a Time...Art Tells Stories of the World], Centro Cultural Banco do Brasil, São Paulo, Brazil, April 21–June 21

Trickle-down Theory – If I get 10 Lexus SUVs, You Might Get a Pair of Flip-flops, Korjaamo Gallery, Helsinki, Finland, April 18–May 10

Nus [Nudes], Galeria Fortes Vilaça and Galeria Bergamin, São Paulo, Brazil, February 14–April 4

Erika Verzutti e Tiago Carneiro da Cunha, Misako & Rosen, Tokyo, Japan, January 26–February 22

2008
Haptic, Tokyo Metropolitan Fundation for History and Culture, Tokyo Wonder Site, Tokyo, Japan, November 22–January 12, 2009

De Perto e de Longe, Paralela 08, Liceu de Artes e Ofícios de São Paulo, São Paulo, Brazil, October 26–December 7

Passagens Secretas [Secret Passages], Centro Cultural São Paulo, São Paulo, Brazil, October 25–December 21

Desenho em Todos os Sentidos [Drawing in all directions] – *Festival de Inverno SESC Estado do Rio de Janeiro*, SESC Petrópolis, Rio de Janeiro, Brazil, July 17–August 3

Legend, Centre Artistique et Culturel, Chamarande, France, May 25–September 28

When Lives Become Form – Contemporary Brazilian Art: 1960 to the Present, Museu de Arte Moderna de São Paulo, Brazil, April 10–June 22; traveled to: Museum of Contemporary Art Tokyo, Tokyo, Japan, October 22–January 12, 2009; Hiroshima City Museum of Contemporary Art, Hiroshima, Japan, January 24–March 1, 2009; Yerba Buena Center for the Arts, San Francisco, California, November 5–January 31, 2010

Martian Museum of Terrestrial Art, Barbican Art Gallery, London, United Kingdom, March 6–May 18

2007
Communism of the Form: Sound + Image + Time – The Strategy of Music Video, Galeria Vermelho, São Paulo, Brazil, July 20–August 4

Mundo Animal, Escola São Paulo, São Paulo, Brazil, July 3–August 3

2006
Paralela 2006, Pavilhão Armando de Arruda Pereira, Parque do Ibirapuera, São Paulo, Brazil, October 7–November 19

Everything must go, VTO Gallery, London, United Kingdom, March 25–April 29

Choque Cultural at Fortes Vilaça and Fortes Vilaça at Choque Cultural, Choque Cultural and Fortes Vilaça, São Paulo, Brazil, March 18–April 20

Desenho Contemporâneo [Contemporary Design], MCO Arte Contemporânea, Porto, Portugal, September 15—October 18

That's Us/Wild Combination, Three Colts Gallery, London, United Kingdom

2005
Education, Look!, A Gentil Carioca, Rio de Janeiro, Brazil, September 17–October 15

Plastic.o.rama, Museu de Arte Moderna do Rio de Janeiro, Brazil, March 17–March 27

2004
Summer Bazaar, Galeria Fortes Vilaça, São Paulo, Brazil, December 20–February 19, 2005

Installation view,
Painted Ladies, Galerie
Peter Kilchmann, Zurich,
Switzerland, 2014

In foreground:
Gravid, 2014
Bronze, concrete and
acrylic
35⅜ x 23⅝ x 11 inches

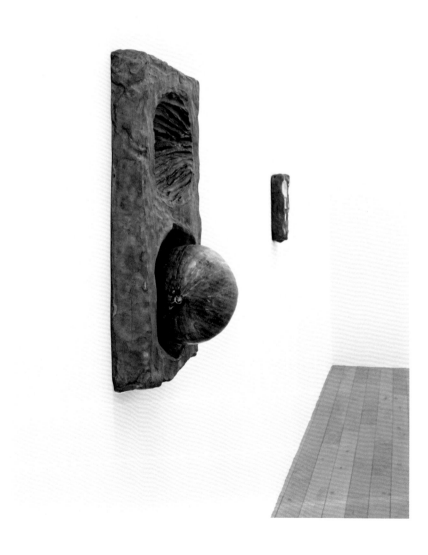

Batalha, 2010
Concrete and pigment
Dimensions variable

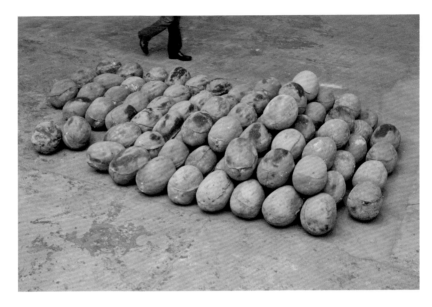

Paralela 2004, Base7, São Paulo, Brazil, September 26–November 14

2003
Colapso, AmpGalaxy, São Paulo, Brazil, October 18–October 29

2002
Feira, Galeria Virgílio, São Paulo, Brazil, December 12–January 26, 2003

poT: The Liverpool Biennial of Contemporary Art–The Independent, Commercial Unit 6 Square, Liverpool, United Kingdom, September 14–November 24; traveled to: Galeria Fortes Vilaça, São Paulo, Brazil, December 19–February 28, 2003

2001
Zig Zag, Galeria Thomas Cohn, São Paulo, Brazil

2000
The Armchair Project, Cinch, London, United Kingdom, October 11–October 28

Assembly, Stepney City, London, United Kingdom, October 5–October 31

1999
non stop opening lisboa, Zé dos Bois Gallery, Lisboa, Portugal

1998
Heranças Contemporâneas [Contemporary Legacies], Museu de Arte Contemporânea da Universidade de São Paulo, São Paulo Brazil, September 25–December 5

Além do Arco Íris [Beyond the Rainbow], Museu de Arte Brasileira, FAAP, São Paulo, Brazil, September 15–October 4

1997
Dublês de Corpos: Visões do Múltiplo Contemporâneo, Galeria Múltipla de Arte, São Paulo, Brazil, September 2–September 24

1996
Antarctica Artes com a Folha, Pavilhão Manoel da Nóbrega, São Paulo, Brazil, September 29–November 17

1995
Works on Paper, Casa Triângulo Gallery, São Paulo, Brazil, March 23–April 13

XI Bienal de Gravura de Curitiba, Curitiba, Brazil

BIBLIOGRAPHY

SELECTED BOOKS, CATALOGUES, AND BROCHURES

Amirsadeghi, Hossein, ed. *Contemporary Art Brazil*. London: Thames and Hudson, 2012. Text by Catherine Petitgas.

Art Cities of the Future: 21st Century Avant Gardes. London: Phaidon Press, 2013.

Baumann, Daniel, Dan Byers, and Tina Kukielski. *2013 Carnegie International*. Exhibition catalogue. Pittsburgh, Pennsylvania: Carnegie Museum of Art, 2013.

Berry, Ian, ed. *Opener 28 Erika Verzutti: Mineral*. Exhibition catalogue. Saratoga Springs, New York: The Frances Young Tang Teaching Museum and Art Gallery at Skidmore College, 2015.

Desenho em todos os sentidos. Festival de Inverno. Rio de Janeiro: Tisara, SESC Nova Friburgo, 2008.

Diegues, Isabel, and Alexandre Gabriel, ed. *Erika Verzutti*. Rio de Janeiro: Cobogó, 2013. Text by José Augusto Riberio.

Era Uma Vez... Arte Conta Histórias do Mundo. Exhibition catalogue. São Paulo: Centro Cultural Banco do Brasil, 2009.

Farinha, Marcos, and Erika Verzutti. *PoT*. Exhibition catalogue. São Paulo: Galeria Fortes Vilaça, 2002.

Gabriel, Alexandre. *Erika Verzutti*. Rio de Janeiro: Cobogó, 2007. Text by Rodrigo Moura.

Gabriel, Alexandre, and Márcia de Moraes. *Galeria Fortes Vilaça*. Gallery catalogue. São Paulo: Cobogó, 2010.

Hasehawa, Yuko, Mari Nakashima, Sachiko Namba, Mihoko Nisikawa, Akio Takashiro, and Kei Wakabay-shi, eds. *Neo Tropicália – When Lives Become Form, Contemporary Brazilian Art: 1960's to the Present*. Tokyo: Museum of Contemporary Art, 2008.

Heranças Contemporâneas. Exhibition catalogue. São Paulo: Museu de Arte Contemporânea da Universidad de São Paulo, 1998.

Manacorda, Francesco, Lydia Yee, and Corina Gardner, eds. *Martian Museum of Terrestrial Art. Encyclopedia of Terrestrial Life. Volume VIII*. London: Barbican Centre, 2008.

Vaillant, Alexis, ed. *BigMinis: Fetishes of Crisis*. Berlin, New York: Sternberg Press, 2010.

Verzutti, Erika. *Iran de Espírito Santo...[et al.]"* Exhibition catalogue. São Paulo: Galeria Fortes Vilaça, 2002.

SELECTED ARTICLES AND REVIEWS

Augusto Ribeiro, José. "O Texto Ótimo do Zé." *www. verzutti.com* (14 March 2012).

Birmingham, Lucy. "Haptic." *Artforum.com* (22 December 2008).

Carter. Alice T. "Carnegie Museum Acquires Works from 2013 International." *Pittsburgh Tribune Review* (17 December 2013).

"Choque na Fortes Vilaça."*O Estado de São Paulo* (9 February 2006).

Cornish, Sam. "What's On – January 2014 (updated)." *Abstract Critical* (17 January 2014).

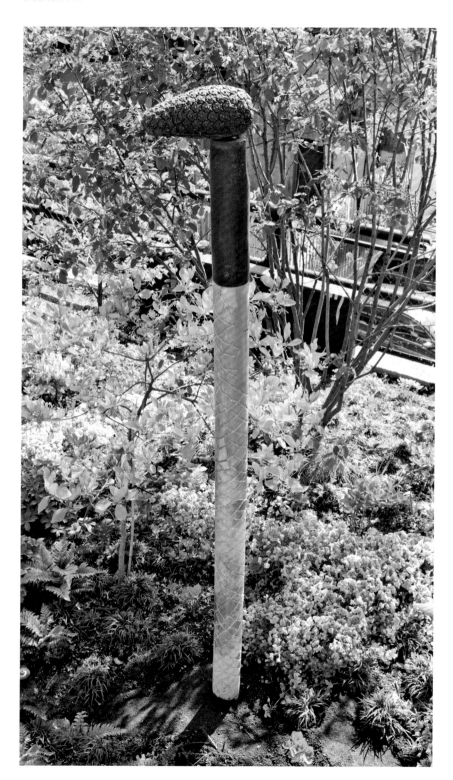

Dino Tropical, 2012
Bronze, concrete
and wax
94½ x 5⅞ x 11¾ inches
Installation view,
Lilliput, Highline, New
York, 2012

Cotter, Holland. "Arriving Late to the Party, but Dancing on All the Clichés." *New York Times* (13 June 2014).

Cypriano, Fabio. "Obras de Antonio Malta e Erika Verzutti fogem do circuito politicamente correto." *Folha de São Paulo* (18 March 2012).

"Especial Antarctica Artes com a Folha." *Folha de São Paulo* (23 March 1996).

Fioravante, Celso. "Gallery Walk: São Paulo." *Art on Paper* 7, no. 82 (May/June 2003): 82.

Furlaneto, Audrey, and Catharina Wrede. "Obra em Progresso." *O Globo* (25 September 2012).

Galvão, Hérmes. "Fora do comum." *Daslu* (November 2006): 82–85.

Leon da la Barra, Pablo. "Erika Verzutti, 'Missionary' at Galpao Fortes Vilaça, São Paulo." *CentrefortheAestheticRevolution.blogspot.com* (14 August 2011).

———. "Erika Verzutti at Swallow Street!" *CentrefortheAestheticRevolution.blogspot.com* (3 September 2009).

"Lilliput – Art Review." *New Yorker* (25 September 2012).

Mariotti, Gilberto and Erika Verzutti. "Gilberto Mariotti entrevista Erika Verzutti." *Fortesvilaca.com.br/blog* (22 October 2008).

Miller, Leigh Anne, "Carnegie Museum Acquires Works by Barlow, Guyton, and Others from International Exhibition." *ArtinAmericaMagazine.com* (16 December 2013).

Molina, Camila. "Exposião celebre a diversidade da América Latina." *O Estadão de São Paulo* (14 June 2014).

———. "Fotos e esculturas em duas mostras na Fortes Vilaça." *O Estadão de São Paulo* (8 July 2003).

———. "Livro e mostras no exterior destacam o sensorial na obra de Erika Verzutti." *O Estadão de São Paulo* (20 July 2014).

Moraes, Angélica de. "Jovens recriam vocabulário." *O Estado de São Paulo* (23 March 1995).

Nagoya, Satornu. "Erika Verzutti." *Flash Art* 47, no. 294 (January/February 2014): 107.

Oliva, Fernando. "Uma casa se enche de arte e abre as portas." *Jornal da Tarde* (30 March 2001).

Pope, Nessia. "A Seriously Playful Carnegie International Brings Welcome Attention to New Artistic Visions." *ArtspaceMagazine.com* (23 October 2013).

Russeth, Andrew. "A Playground in Pittsburgh: The 2013 Carnegie International Is a Quiet Triumph." *Galleristny.com* (10 August 2013).

Solway, Diane. "Walking the Line." *W Magazine* (March 2013).

Sutton, Benjamin. "See the Diminutive Sculptures From the High Line's First Group Show, 'Lilliput.'" *In the Air* (25 April 2012).

"The 2013 Carnegie International: Museum within a Museum." *Ohio Starr Review* (16 October 2013).

Thomas, Mary. *"Who's Who;
Triennial Global Art Show
Breaks Away from Predeces-
sors in its Approach."*
Pittsburgh Post-Gazette
(3 April 2013).

Ventura, Mauro. "Artistas
interpretam o espaço íntimo
do devaneio e do aprision-
amento." *O Globo* (6 July
2009).

Verzutti, Erika. "500 Words:
Erika Verzutti." *Artforum.com*
(18 July 2014).

Yablonsky, Linda. "Artifacts
– Gilding the 'Lilliput'."
TMagazine.blog.nytimes.com
(30 April 2013).

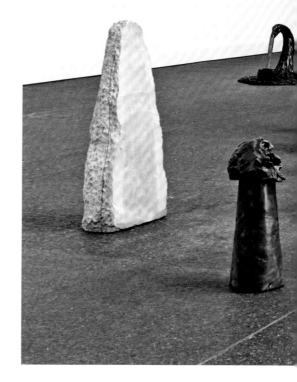

Installation view, *2013
Carnegie International*,
Carnegie Museum of Art,
Pittsburgh, Pennsylvania,
2013

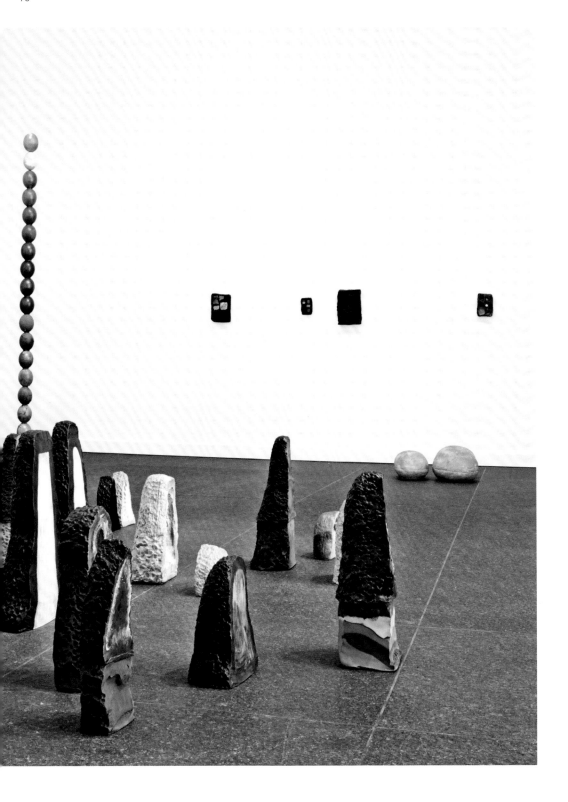

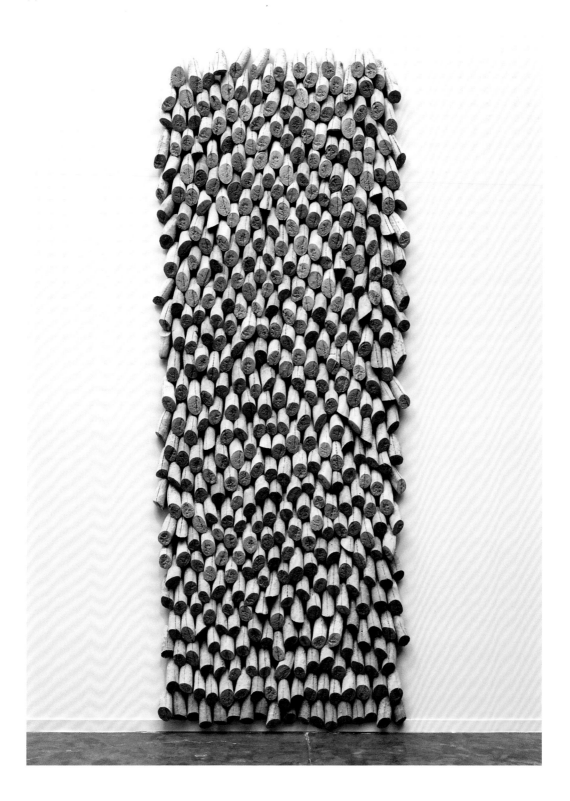

ACKNOWLEDGMENTS

THE TANG MUSEUM IS PLEASED TO PRESENT the first solo exhibition of Erika Verzutti in the United States. Verzutti's room of sculptures at the 2013 Carnegie International was inspirational, and since then I have watched her and her work find diverse new audiences and dive into performance and new materials with gusto. Thanks to Dan Byers for introducing me to Erika's work and to Alex Gabriel, Tina Kukielski and Ruba Katrib for their encouragement.

Thanks to the lenders to the exhibition: Carnegie Museum of Art, Galeria Fortes Vilaça, and Rodrigo Ferreira da Rocha. Special thanks to the entire staff of Galeria Fortes Vilaça including Laura Moritz, Leticia Florence Orsi, Amanda Rodrigues Alves, and especially Alex Gabriel. Thanks also to Peter Kilchmann and Andrew Kreps for their advice and support.

Thanks to the New York State Council on the Arts, Overbrook Foundation and Friends of the Tang for their ongoing support of Opener exhibitions and publications. Thank you to Beverly Joel, who continues to design each volume in the Opener series with great attention to detail. Thanks to many photographers whose work is reproduced here, and my continued appreciation and gratitude goes to Jay Rogoff, Megan Hyde, and Jenna Postler for their editorial assistance.

Thanks to our installation crew: Luke Anderson, Samuel Coe, Pat Girard, Lauri Kobar, Ira Martin, and David Paarlberg-Kvam. Thanks to the entire Tang staff for all they do to support the series: Caroline DeClercq-Blake, Jeanne Eddy, Ginger Ertz, Torrance Fish, Megan Hyde, Elizabeth Karp, Michael Janairo, Naomi Meyer, Jennifer Napierski, Patrick O'Rourke, Barbara Schrade, Rachel Seligman, Kelly Ward, and Cynthia Zellner. Thanks also to our student intern Rebecca Baruc '15.

Our most heartfelt affection and thanks to Erika for her openness and collaboration with us—we are honored to show your work and look forward to many more projects in the future. —Ian Berry

(facing)

Banco/Bank, 2013
Concrete
108¾ x 41¼ x 4 inches

This catalogue accompanies the exhibition

OPENER 28
ERIKA VERZUTTI: MINERAL

The Frances Young Tang Teaching Museum and Art Gallery at Skidmore College Saratoga Springs, New York July 5–November 16, 2014

The Frances Young Tang Teaching Museum and Art Gallery Skidmore College 815 North Broadway Saratoga Springs, New York 12866 T 518 580 8080 F 518 580 5069 www.skidmore.edu/tang

State of the Arts

NYSCA

This exhibition and publication are made possible in part with public funds from the New York State Council on the Arts, a state agency, the Overbrook Foundation, Ann Schapps Schaffer '62 and Mel Schaffer, Beverly Beatson Grossman '58, and the Friends of the Tang.

ISBN: 9780989956611
Library of Congress Control Number: 2015918179

Designed by Beverly Joel, pulp, ink.

Printed in Italy by Conti Tipocolor

Cover:
Murundum/Stone Cemetery, 2013
Cobblestones, clay, concrete and stones
33½ x 90½ x 15¾ inches

Page 1:
Studio view

Page 2:
Peacock, 2014
Papier-mâché, brushes and iridescent paint
35⅞ x 35⅞ x 7⅞ inches

All works illustrated in this book are courtesy of the artist and Galeria Fortes Vilaça, São Paulo; Allison Jacques Gallery, London; Galerie Peter Kilchmann, Zurich; Andrew Kreps Gallery, New York; and Misako and Rosen Gallery, Tokyo, unless otherwise noted.

All images in this catalogue, unless otherwise noted, are copyright of the artist.

All photographs by Eduardo Ortega, courtesy of Galeria Fortes Vilaça, São Paulo except those noted below:
Page 1: Erika Verzutti
Page 2, 40–41, 58–59, 65, 66, 67, 75, 87: Thomas Strub, courtesy of Galerie Peter Kilchmann, Zurich
Page 9, 10, 22, 23, 27, 29: Denise Andrade, courtesy of Galeria Fortes Vilaça, São Paulo
Page 30, 34: Kei Okano, courtesy of Misako and Rosen Gallery, Tokyo
Page 37: Andy Keate
Page 47, 54: Courtesy of Solomon R. Guggenheim Museum, New York
Page 62–63, 72, 73: Sebastiano Pellion di Persano, courtesy of Galeria Fortes Vilaça, São Paulo
Page 68–69, 70, 71: Arthur Evans
Page 92–93: Greenhouse Media, courtesy of Carnegie Museum of Art. Pittsburgh
Page 94: Everton Ballardin, courtesy of Galeria Fortes Vilaça, São Paulo